POSTCARD HISTORY SERIES

Dallas Landmarks

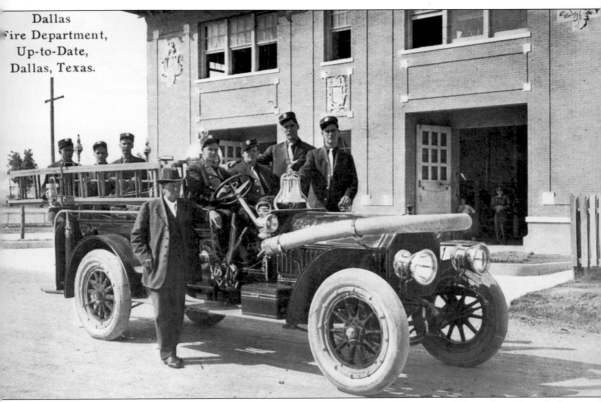

Dallas
Fire Department,
Up-to-Date,
Dallas, Texas.

FIRE STATION NO. 11. Few neighborhood buildings in Dallas are as beloved as the city's oldest operating fire station, located at 3828 Cedar Springs Road. Designed by Dallas architects Hubbell and Greene in 1909, the Alamo Revival-style building has wide bracketed eaves to shade the windows, a series of decorative panels with "1909" carved in them, and the fire department logo. The only change is a double-center door, which replaced a smaller entry door. (Courtesy private collection.)

FRONT COVER: This view of the Dallas skyline from the Houston Street Viaduct was a familiar sight during the middle of the 20th century. Travelers approaching from the southwest, and Oak Cliff residents who crossed the Trinity River via the bridge on their way to work or shop in downtown, enjoyed the stately buildings that symbolized a progressive, business-oriented city.

BACK COVER: Large letter postcards celebrate the towns they represent by showing a variety of views within the letters. They were an easy choice for the busy traveler who could not decide which card to purchase. This view from the second decade of the 20th century features a variety of historic structures in the letters, including Union Station, the Houston Street Viaduct, and the Dallas Country Club.

POSTCARD HISTORY SERIES

Dallas Landmarks

Preservation Dallas and Dallas Heritage Village

ARCADIA
PUBLISHING

Published by Arcadia Publishing
Charleston SC, Chicago IL, Portsmouth NH, San Francisco CA

Printed in the United States of America

Library of Congress Catalog Card Number: 2008931754

For all general information contact Arcadia Publishing at:
Telephone 843-853-2070
Fax 843-853-0044
E-mail sales@arcadiapublishing.com
For customer service and orders:
Toll-Free 1-888-313-2665

Visit us on the Internet at www.arcadiapublishing.com

CONTENTS

ACKNOWLEDGMENTS

Creating this book has been a labor of love completed by a dedicated group of volunteers. Carol Roark and Marsha Prior, vice presidents for preservation education on the board of Preservation Dallas, spearheaded the project by selecting postcards for reproduction and writing many of the captions. Evelyn Montgomery, curator of collections at Dallas Heritage Village, managed the scanning process assisted by Karen Pirinelli and Max Painter. Greg Bognich and Adele Powers facilitated the selection of the postcards. A team of local historians, including Susan Besser, Sam Childers, Victoria Clow, Nicky Emery, and Jackie McElhaney, wrote captions. Dr. Michael V. Hazel provided additional captions, helped edit the copy, and wrote the introduction. Warm thanks go to Katherine Seale, executive director of Preservation Dallas, and Gary Smith, president and executive director of Dallas Heritage Village, who have both provided strong support for this project.

Unless otherwise noted, all postcards in this book come from the Irene Carnes Postcard Collection at Dallas Heritage Village. Others who have generously made cards available from their collections include Errol Miller, Andy Hanson, the Old Red Museum of Dallas County History and Culture, the Texas/Dallas History and Archives Division of the Dallas Public Library (DPL), and a private collector.

INTRODUCTION

Founded in 1841 by John Neely Bryan on the east bank of the Trinity River in the then unpopulated region of North Central Texas, Dallas grew slowly as a frontier market town and county seat until after the Civil War. Almost nothing remains of this early era except a log cabin near the courthouse that traditionally has been identified as Bryan's (though historians now believe it might have belonged to another pioneer) and several restored structures at Dallas Heritage Village, a museum of architectural and cultural history on the southern edge of downtown.

The arrival of two railroads in 1872 and 1873 transformed Dallas into a boomtown, which became the transportation center for North Texas. By 1890, it was the largest city in Texas, the world's largest inland cotton market, and host to the annual state fair. With prosperity came more substantial stone and brick buildings—some of which still survive. But because Dallas has always been a forward-looking place, many architectural gems were lost to progress in the form of larger, taller buildings; wider roads and highways; and even parking lots. Despite the changes, the Old Red Courthouse, the First Baptist Church (from the 1890s), the Roman Catholic Sacred Heart Cathedral (now Santuario Guadalupe), the Wilson Building, the Adolphus Hotel, and the Busch-Kirby Building (from the early 20th century), among others, are still here, well preserved, and in active use.

The selection of Dallas in 1914 as headquarters for the 11th District of the Federal Reserve Bank consolidated its position as the financial center of the Southwest, sparking a competition among the leading banks to erect the tallest building downtown. Most of these survive, though none are banks anymore; even the Federal Reserve has moved to new headquarters. By the 1920s, the skyline boasted the tallest building west of the Mississippi—the headquarters of oil-company Magnolia Petroleum, which foresaw the impact on the regional economy from the discovery of the East Texas oil fields in 1930. The revenue and satellite businesses spawned by that discovery mitigated the impact of the Great Depression, and in 1936, Dallas hosted the Texas Centennial Exposition, a world's fair celebrating the anniversary of the state's independence from Mexico. This was the era when Dallas began to be known as "Big D." After World War II, Dallas found itself at the geographic center of the emerging "Sunbelt," home to high-tech industries, major medical centers, universities, and cultural attractions. The motto of R. L. Thornton, Dallas's mayor through most of the 1950s, was "keep the dirt flying," and the skyscrapers raised during that period dwarfed the stately edifices of earlier decades.

Dallas has always been a "booster" city, ready to toot its own horn. The golden age of postcards, lasting roughly from 1905 till 1930, provided the perfect mechanism for promoting

the wonders of the rapidly expanding community. With each new bank, office building (especially downtown high-rises), school, or hospital came a dramatic change in the skyline that brought forth a new, usually hand-colored, card. Captions on the cards might brag that the Houston Street Viaduct was "the longest concrete bridge in the world," or that a scenic watercourse was "the head of navigation on the Trinity River"—claims of questionable validity at best. But Dallas residents were proud of their city and eager to broadcast its achievements to the world.

Produced as ephemera, with no intention of lasting value, these postcards became collectible over time, especially as the scenes represented on them began to disappear. Not only were they nostalgic reminders of an earlier era, they also often provided documentation of a building or street scene not widely available in photographs or other sources.

These historic postcards document what Dallasites and visitors valued, at least as perceived by the publishers who produced and distributed the cards for sale. Downtown buildings and streetscapes were very popular, and churches and schools tend to be well represented. So, too, are places of amusement, especially Fair Park, which merits an entire chapter in this book. Residences are harder to find, though upscale neighborhoods such as Highland Park and Munger Place were depicted. Thus, it is delightful to come across a card such as the one of Mr. and Mrs. Potts standing proudly on the front porch of their new home in Greenway Parks. As a transportation center (after the railroads came automobiles and then airplanes), it is not surprising that quite a few postcards depict train depots, airports, highways, and even toll plazas.

The editors of this book have saved the most poignant cards for last. These depict buildings gone but not forgotten. The chapter opens with a card featuring the old Carnegie Library, a stately Neoclassical edifice, which was a temple to the value of literacy but also a gracious and welcoming building. Old photographs document the beautiful marble reception desk and the high-ceilinged reading rooms. Today preservationists would mount a vigorous campaign to defeat the very idea of tearing down such an architecturally beautiful, as well as historically significant, structure. But in the 1950s, the library was considered just an old, outdated building, ready for the wrecking ball. Ironically it was replaced with a Mid-Century Modern structure that served barely 25 years before being abandoned and has now sat empty for another 25 years.

It is the hope of Dallas Heritage Village and Preservation Dallas, the two organizations sponsoring this book, that viewing these lost treasures will encourage the preservation of those that remain. Not only are survivors often objects of grace and beauty in themselves, or projects designed by eminent architects, but they are tangible links to this city's history, reminders of the significance of cotton, oil, banking, and insurance to the city's economy; of houses of worship and schools to its spiritual and intellectual life; and of theaters, parks, and museums to its culture and entertainment. These are buildings and sites that helped define Dallas and gave it a unique identity. Only by appreciating them can citizens of today make informed decisions about the future.

One

BUSINESSES

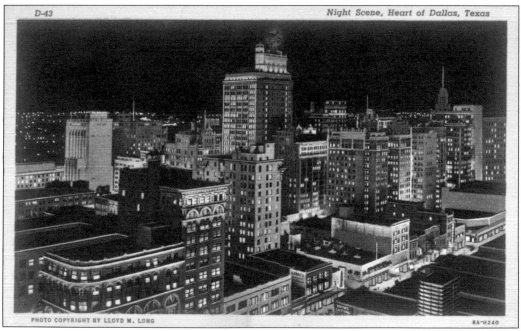

DOWNTOWN DALLAS AT NIGHT. Aerial photographer Lloyd M. Long's mid–1930s view of downtown Dallas is an iconic image that has been reproduced on everything from postcards to telephone book covers. Every building sparkles with lights, lending an air of prosperity to the Depression-era skyline. Many of the historic structures in this book can be seen in this card. The Wilson Building is at the lower left, and the Dallas Power and Light Building is the light-colored tower behind it. The mid-rise structure to the right of the Wilson Building is the Praetorian, and the Magnolia Building with Pegasus atop it centers the image. Next in line to the right are the Adolphus Hotel and the crenellated top of the Kirby Building, followed by the rounded cupola and spire of the Davis Building in the upper right. (Courtesy Andy Hanson.)

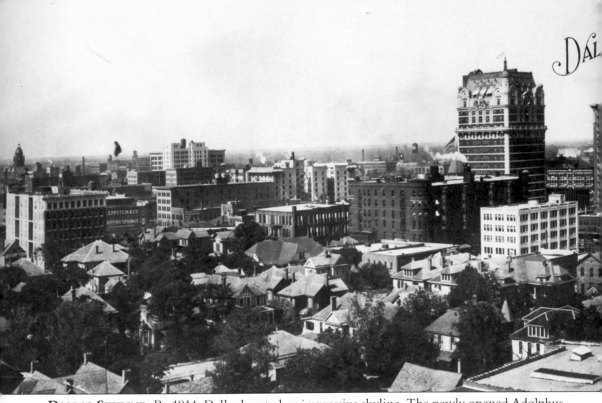

DALLAS SKYLINE. By 1914, Dallas boasted an impressive skyline. The newly opened Adolphus Hotel (center left), completed in late 1912 by St. Louis beer magnate Adolphus Busch, and the Southwestern Life Building (center right), designed by noted Dallas architect Otto Lang, dominate this view. Directly across Commerce Street from the Adolphus can be seen the turret of the Oriental Hotel. The site of visits by presidents Theodore Roosevelt and William Howard

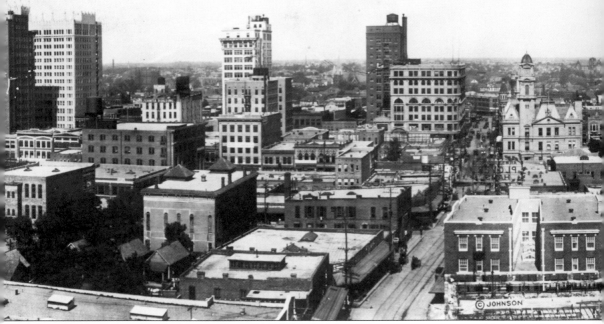

Taft, the Oriental was considered the most elegant in Dallas. Other notable buildings in this bird's-eye view are the 1892 "Old Red" Courthouse (far left), 1889 U.S. Post Office and Federal Building (far right), the 1904 Wilson Building (left of the post office in this view), the 1909 Praetorian Building (center right), and the Gothic 1913 Kirby Building (center). Note the large number of homes in the central business district.

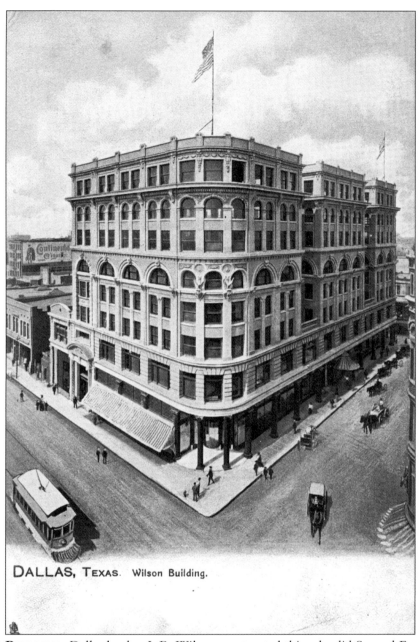

DALLAS, TEXAS. Wilson Building.

WILSON BUILDING. Dallas banker J. B. Wilson constructed this splendid Second Empire–style building in 1903 to house the Titche-Goettinger department store, with offices on the seven floors above. The recessed open areas between the building sections provided light and air movement, which were very important in the time period before air-conditioning. Designed by noted Fort Worth architects Sanguinet and Staats, the Wilson Building is one of Dallas's best early-20th-century structures. Titche-Goettinger remained here until 1929 when they moved to another building two blocks east on Main Street, and H. L. Green moved in. Green's, a discount department store, was sometimes called "the poor man's Neiman Marcus" in reference to the upscale department store across Main Street. H. L. Green closed in 1997, and the Wilson Building was restored in 1999 with restaurants on the ground floor and apartments above.

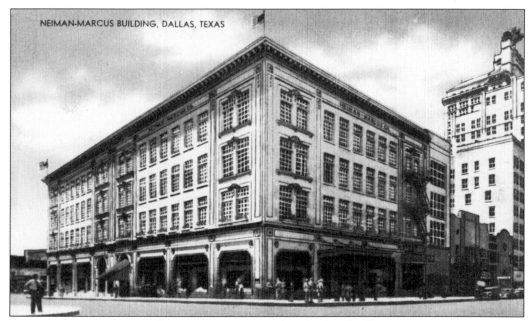

NEIMAN MARCUS. Founders Carrie Neiman, her husband Al Neiman, and her brother Herbert Marcus built their first store at the corner of Main and Murphy Streets in 1907. The store concentrated on providing high-quality, ready-to-wear clothing to wealthy customers. In 1913, the store burned, and this new store was built at the corner of Main and Ervay Streets. It was later expanded from three floors to nine with an addition to the west.

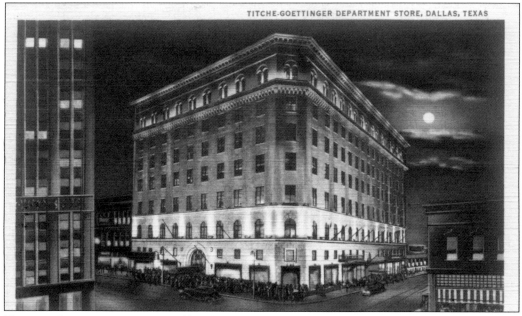

TITCHE-GOETTINGER DEPARTMENT STORE, DALLAS, TEXAS

TITCHE-GOETTINGER. Inspired by the Pitti Palace in Florence, Italy, architect George Dahl designed this Renaissance Revival palazzo in 1929 to house Titche-Goettinger, a leading department store, which had previously occupied part of the Wilson Building a block away. Located on St. Paul Street, between Main and Commerce Streets, the building has been converted into loft apartments. (Courtesy Andy Hanson.)

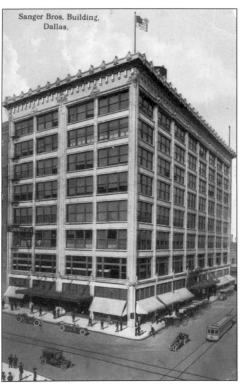

SANGER BROTHERS. Opened in Dallas in 1872, Sanger Brothers department store expanded to encompass the entire block bounded by Main, Elm, Lamar, and Market Streets. In 1910, architects Lang and Witchell designed this eight-story building facing Lamar to create what has been called Dallas's finest example of the Chicago School of commercial architecture. Since 1977, the building has housed Dallas County Community College District's El Centro campus. (Courtesy Andy Hanson.)

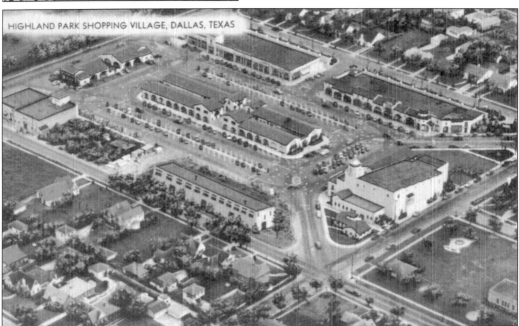

HIGHLAND PARK SHOPPING VILLAGE. Highland Park Village was the first shopping complex in the nation to integrate retail and off-street parking. Developer Hugh Prather and architects Fooshee and Cheek were inspired by the layout of the Texas courthouse squares, and the initial design provided off-street parking for 650 vehicles. The buildings, most completed between 1931 and 1953, were inspired by Texas and California missions as well as Spanish architecture.

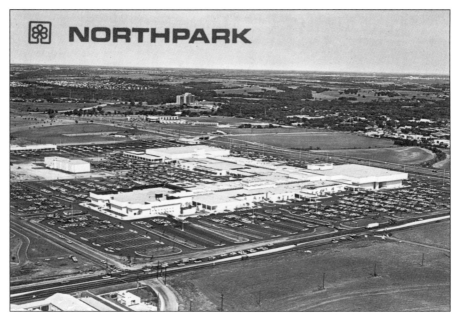

NORTHPARK. Retail, aesthetics, and technology merged in 1965 with the opening of NorthPark, a 94-acre complex at Central Expressway and Northwest Highway. Under the guidance of businessman Raymond Nasher, the Dallas architectural firm Harrell and Hamilton designed a modern L-shaped complex using white sand-finished brick. With an eye toward beauty, Nasher ensured that NorthPark, the world's largest air-conditioned mall at the time, was aesthetically pleasing. The renowned landscape architectural firm, Lawrence Halprin and Associates, collaborated with Richard Myrick to provide a relaxing, park-like feel. Landscape features included indoor fountains, plants, reflecting pools, and benches. The list of tenants read like a who's who of prominent retailers with Neiman Marcus, Titche-Goettinger, and J. C. Penney joining nearly 80 other businesses. Recent additions have redefined the footprint, but NorthPark continues to attract residents and visitors alike.

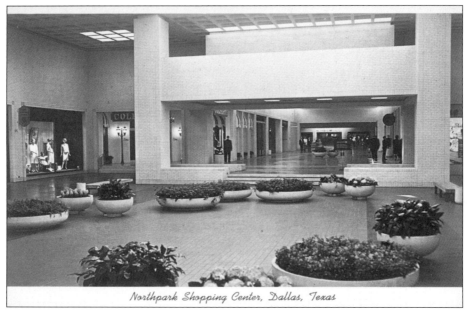

Northpark Shopping Center, Dallas, Texas

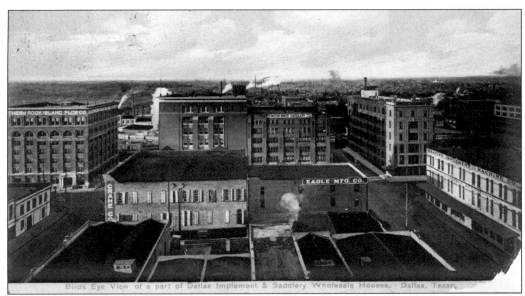

Birds Eye View of a part of Dallas Implement & Saddlery Wholesale Houses. Dallas, Texas.

WEST END. In 1900, Dallas had the largest farm-implement market in the country. Now known as the West End Historic District, many distributors were located in a group of warehouse and wholesale showrooms. The Southern Rock Island Plow Company Building on the left is probably the best known of these structures because it became the Texas School Book Depository from which Lee Harvey Oswald allegedly shot Pres. John F. Kennedy.

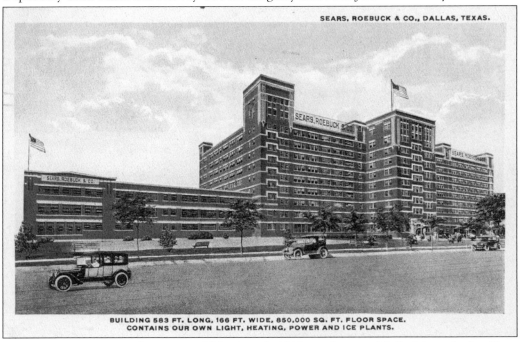

SEARS, ROEBUCK & CO., DALLAS, TEXAS.

BUILDING 583 FT. LONG, 166 FT. WIDE, 850,000 SQ. FT. FLOOR SPACE.
CONTAINS OUR OWN LIGHT, HEATING, POWER AND ICE PLANTS.

SEARS, ROEBUCK AND COMPANY. This gigantic 1914 warehouse with Prairie-style detailing, the first built by Sears outside of Chicago, housed the company's catalog distribution center from 1914 until 1993. After additions by the original Dallas architects, Lang and Witchell, in 1915 and 1916, the building totaled 1.5 million square feet of floor space. In 2002, the complex was rechristened South Side on Lamar and became home to 457 loft apartments.

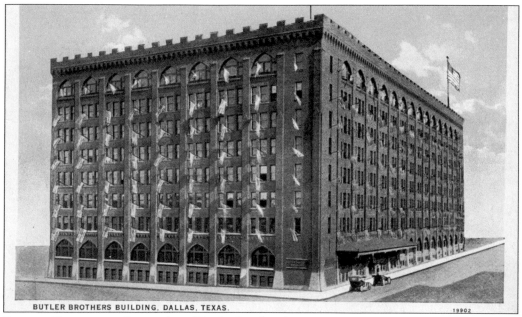

BUTLER BROTHERS BUILDING, DALLAS, TEXAS.

BUTLER BROTHERS. Boston-based Butler Brothers began as a dry goods wholesaler, promoting its merchandise through catalogs rather than traveling salesmen. It established a branch in Dallas in 1906 and was so successful that in 1910 the company constructed this eight-story red brick building that was doubled in size in 1917. Butler Brothers later sold the building, which was modernized and renamed the Merchandise Mart, a predecessor to the Dallas Market Center.

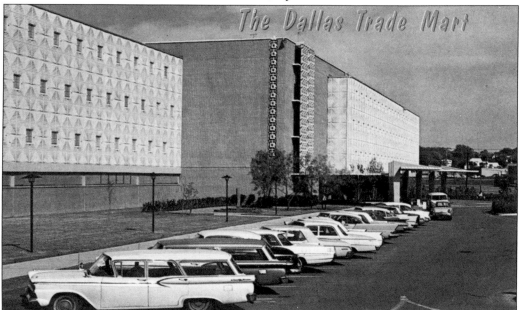

DALLAS TRADE MART. Located on Stemmons Freeway, the $18 million, 500,000-square-foot Trade Mart quickly launched Dallas to the top position in the wholesale home-furnishings market when it opened in 1959. One floor showcased furniture, and the remaining three were stocked with accessories. With additions in 1976 and 2007, the Trade Mart stands at 2 million square feet and continues to set records in the wholesale business.

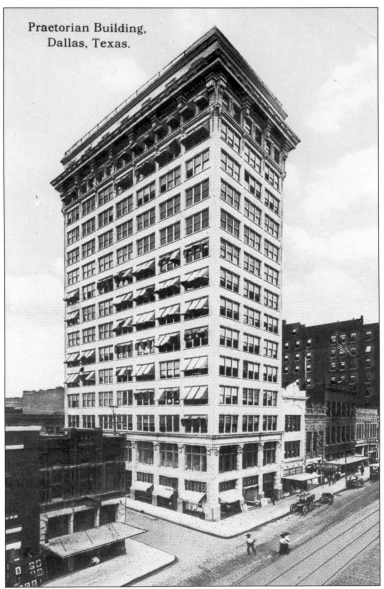

Praetorian Building,
Dallas, Texas.

PRAETORIAN BUILDING. By the late 19th century, Dallas had emerged as a regional center for the insurance industry, and architect Clarence Bulger was commissioned to design this Neoclassical building as the headquarters for the Praetorians, a fraternal insurance society. Considered by many as the first skyscraper in the Southwest, the 14-story Praetorian Building opened in July 1909. Constructed with an interior structure of steel (another first for a tall building in the city), the building offered visitors the opportunity to ascend to the rooftop for the view, where the visibility one person said "was good for 20 miles." The facade was originally clad in light-colored brick and terra-cotta and ornamented with gray granite columns, gold ornamentation, and terra-cotta pillars, but its most distinctive feature was a 15-foot cornice. The building underwent an unusual renovation in 1959, when a larger structure was constructed around its original steel frame, doubling the building's floor space and completely changing its facade to a modern look. The Praetorians occupied the building until 1987. (Courtesy Errol Miller.)

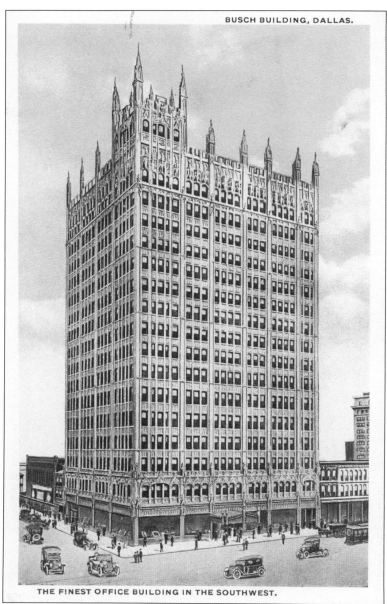

BUSCH BUILDING, DALLAS.

THE FINEST OFFICE BUILDING IN THE SOUTHWEST.

BUSCH (KIRBY) BUILDING. Dallas citizens were introduced to a new architectural style in 1913, when the Busch Building became the first Gothic-style commercial building constructed in the Southwest. Adolphus Busch constructed the 17-story retail/office building to complement the Adolphus Hotel a block away. Molded terra-cotta (glazed brick) that was cream colored made the building's ornate design affordable, as it would have been too expensive to execute the Gothic tracery in cut stone. The Kirby Investment Group purchased the building in 1918 and changed its name. The first and longest remaining tenant was the A. Harris Department Store, which occupied the building between 1913 and 1965. The Kirby Building was converted into residences in 1999. Hall Financial Group retained the original hallway office doors, which featured a frosted-glass pane at the top. They placed a solid wood panel behind the glass on the apartment side of each door, offering residents privacy while maintaining the charm of the historic doors.

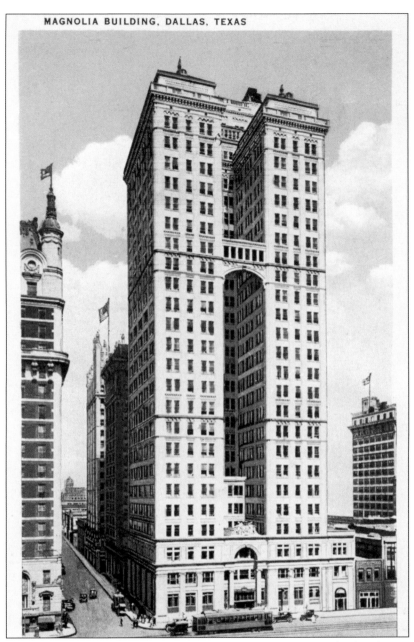

MAGNOLIA BUILDING. The Magnolia Building was constructed as the headquarters for the Magnolia Petroleum Company, producer of Socony and, later, Mobil petroleum products. Located first in Corsicana, Magnolia's move to Dallas symbolized the city's growing importance in the oil industry even before the discovery of oil in East Texas in 1930. When finished in 1922 at a cost of $4 million, the Magnolia Building was the tallest building in Dallas, and at 29 stories, it was the 16th-tallest building in the country. English architect Sir Alfred C. Bossom was influenced by Mayan architecture and utilized this to inform the largely Renaissance Revival–style building. A central light well separates the symmetrical office wings that rise from a three-story base. A flying arch at the 17th floor joins the wings. The Magnolia has been converted to a boutique hotel.

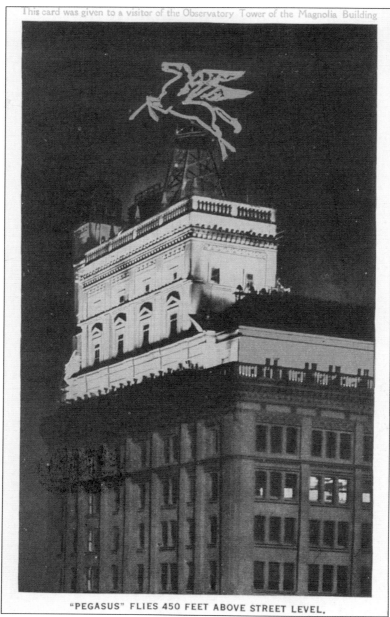

"PEGASUS" FLIES 450 FEET ABOVE STREET LEVEL.

PEGASUS. Generations of residents and visitors remember seeing the red neon glow of Pegasus, the flying horse atop the Magnolia Building, as they traveled towards Dallas. For visitors, it signified the rich business and entertainment opportunities available in Big D, and those who lived in Dallas knew that they were home. The double-faced revolving logo for Magnolia Petroleum (later Mobil Oil), measuring 32 feet by 40 feet and lit with 1,000 feet of neon tubing, was placed atop the building in 1934. It did not take long for the distinctive emblem to transcend its original commercial purpose, and Pegasus became a symbol for the spirit of Dallas that is often found on T-shirts and other gift items. It also offered punsters the opportunity to joke that Dallas was no longer a one-horse town. Following a massive community preservation effort, a replica of the original still shines today atop the Magnolia, providing a distinctive sparkle to the Dallas skyline.

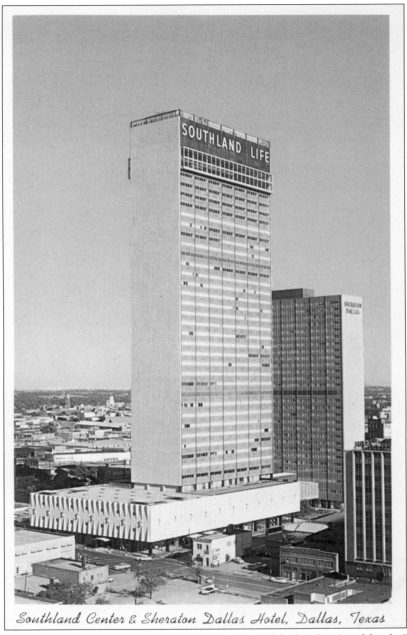

Southland Center & Sheraton Dallas Hotel, Dallas, Texas

SOUTHLAND LIFE BUILDING. Covering an entire city block, the Southland Center was completed in 1959 and used as the headquarters for the Southland Life Insurance Company. It was the tallest office building west of the Mississippi when it opened. The "City Within a City" project included the 42-story office building, 28-story Sheraton hotel, street-level shopping arcade, 5-story parking garage, and a rooftop heliport. The tower is remembered by longtime residents as the home of the Ports O' Call restaurant, known for its exotic Polynesian decor and incredible views from its location on the 36th floor. Originally clad in distinctive blue mosaic tile panels, the building was renovated in 1998, and the panels were covered with gray paint. After being sold in 1990, the complex housed hotels under a variety of names, and in 2008, it reopened as a Sheraton hotel.

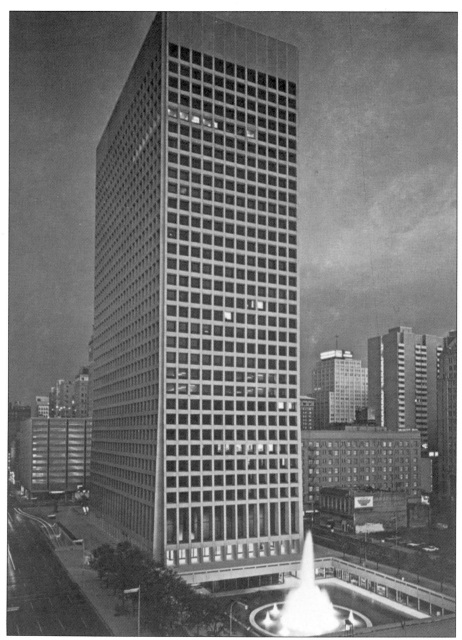

ONE MAIN PLACE. Developed by W. T. Overton and designed by Gordon Bunshaft, an employee of Skidmore, Owings and Merrill, the 34-story tower of Stone Mountain granite was completed in December 1968. It featured computerized air-conditioning and heating and an open plaza one floor below street level that was surrounded by shops and restaurants. During construction of the building, a strip of Elm Street adjacent to the site caved in, leaving a 200-yard-long, 20-foot-wide depression some 15 feet deep. Engineers and geologists never conclusively determined the cause but attributed the shifts in rock strata beneath the construction as a likely explanation. In 1970, the Dallas chapter of the American Institute of Architects, designated the building a milestone recipient in its design awards for the past decade, and it has been called "the most significant downtown building of the 1960s."

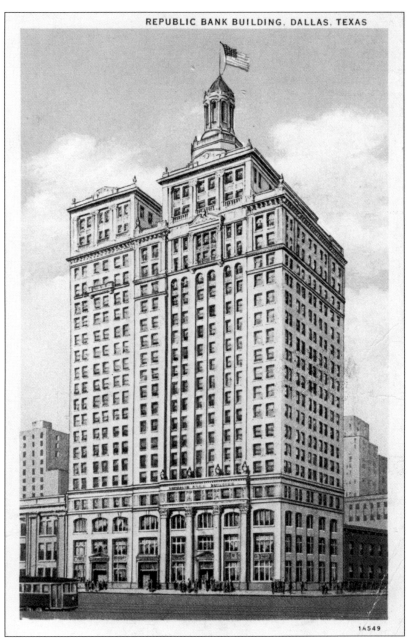

REPUBLIC BANK BUILDING, DALLAS, TEXAS

1A549

REPUBLIC BANK BUILDING (DAVIS BUILDING). Constructed as the second tallest building in Dallas, the Classical Revival-style Republic Bank Building was designed by Dallas architect C. D. Hill. The first wing, topped with a gilded cupola, was completed in 1926. The 20-story west wing followed in 1931. An example of Dallas's relative stability even in the midst of the Great Depression, the addition made it the largest office building in the state. Serving as the Republic National Bank until 1954, it was renamed the Davis Building after businessman Wirt Davis when the bank moved to new headquarters on Ervay Street. Interior renovations began in 1965 and were completed in 1967, joining the building to Dallas's underground tunnel system. In 2003, a $35-million renovation converted the building to house retail on the ground floor and loft apartments above.

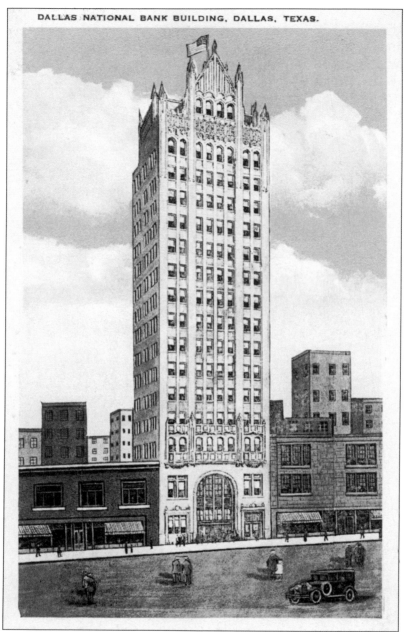

DALLAS NATIONAL BANK BUILDING, DALLAS, TEXAS.

DALLAS NATIONAL BANK BUILDING. Stylish and slender, this 16-story Gothic Revival–style high-rise was constructed for the Dallas National Bank at 1530 Main Street in 1927. Dallas National Bank had served the city since its origination as the Trust Company of Dallas in 1903. A two-story annex was added at the rear of the building in 1933. The Dallas Bank and Trust Company used the building until 1954 when it was absorbed into the First National Bank of Dallas. The building underwent renovations in 1985 when the windows on the Main Street facade were replaced. It has been converted into the luxury hotel Joule, and many of the architectural details that had been removed during prior renovations of the Main Street facade have been restored. New additions include a swimming pool near the top that juts out over the sidewalk like a balcony.

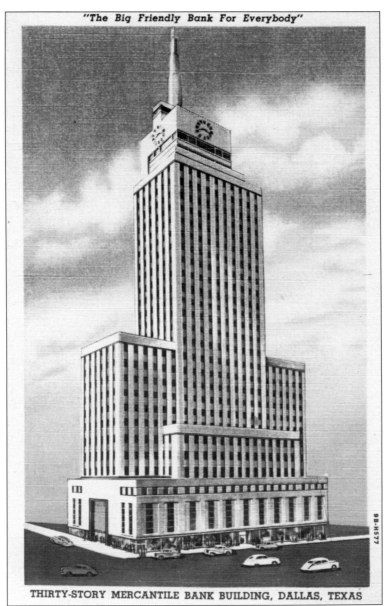

"The Big Friendly Bank For Everybody"

THIRTY-STORY MERCANTILE BANK BUILDING, DALLAS, TEXAS

MERCANTILE BANK BUILDING. When completed in 1943, this 36-story skyscraper, designed by New York architect Walter Ahlschlager, was the tallest building in Texas, surpassing the Magnolia Building, where the bank had been located for a number of years. Headed by Robert L. Thornton, the Mercantile Bank, at 1704 Main Street, was a prominent financial institution. Despite wartime restrictions on the use of steel for nonmilitary projects, Thornton obtained permission to proceed with construction by arguing that the steel scaffolding had already been ordered. Still, the metal shortage prompted a heavy reliance on glass for interior features. The four giant clocks in the tower, 20 feet wide and neon lit at night, were called "new sentinels to mark time for the city's growth." The lavish interior included two giant mosaics—the largest wood murals in the world—depicting the history of Dallas. Now known as Mercantile Place on Main, the building has been converted to apartments and office and retail space in one of the most ambitious urban rehabilitation projects in the city.

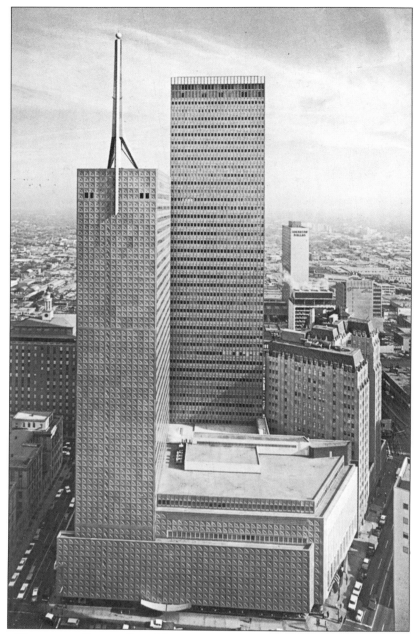

REPUBLIC NATIONAL BANK. Republic National Bank, at the corner of Pacific and Ervay Streets, was designed by Walter K. Harrison, architect of the United Nations Headquarters in New York City as well as the Alcoa Building in Pittsburgh. It was the city's first major project after World War II and was the new headquarters for the bank, which moved from its location at 1309 Main Street. The initial construction phase consisted of a 36-story tower topped with a 150-foot lighted sculpture and an eight-story bank. Clad in aluminum panels, it was the second building in the United States finished with the material. A second tower by Harrell and Hamilton was added in 1964 and a third, by Omniplan, in 1978. Renovations to convert the building into luxury apartments were begun in 2005 by RTKL Architects, and Republic National Bank reopened two years later as Gables Republic Tower.

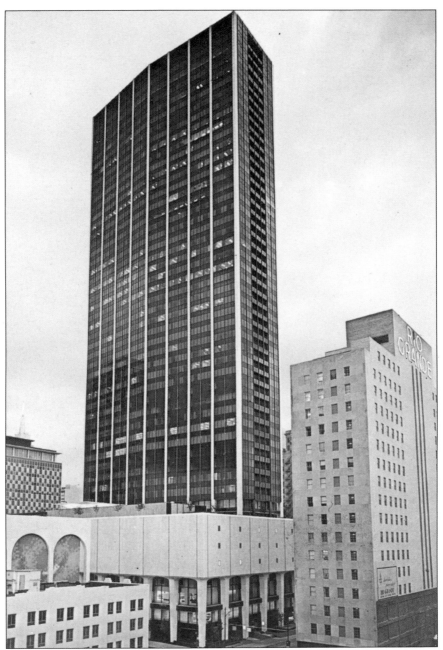

FIRST NATIONAL BANK. The First National Bank at 1401 Elm Street, designed by Dallas architect George Dahl, was one of the last bank buildings constructed in the downtown area before the banking industry expanded into the suburbs. When completed in 1965, it was Dallas's tallest building at 52 stories and 625 feet, and it later became the standard by which tall buildings on the skyline were judged. The building's arched base alone is six stories tall and encompasses the entire city block, while the lower two floors of the base are recessed, providing walkways around the structure. Originally the building's white vertical elements were lit nightly. Now these elements are brightly lit at Christmas with seasonal colors. Bank of America continues to operate a branch bank at the location, which remains one of Dallas's tallest edifices.

DALLAS POWER AND LIGHT. Designed by Lang and Witchell for Dallas Power and Light Company in 1931, this Zigzag Moderne Art Deco building, with strong vertical emphasis and sharp angles, reflected the raw energy and power of the owner's commodity—electricity. Located at 1506 Commerce Street, it was the tallest electrically welded steel-frame building south of the Mason Dixon line. This skyscraper was converted into apartments in 2005.

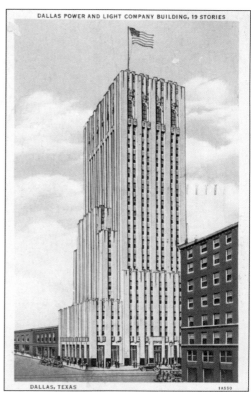

DALLAS POWER AND LIGHT COMPANY BUILDING, 19 STORIES

DALLAS, TEXAS

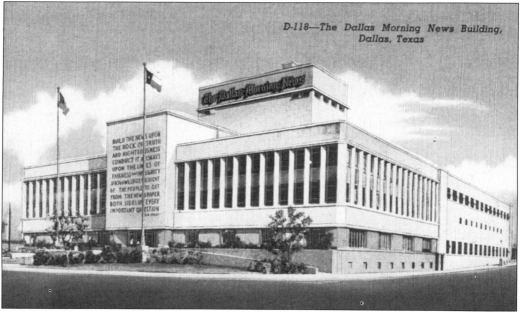

D-118—The Dallas Morning News Building, Dallas, Texas

DALLAS MORNING NEWS BUILDING. Dallas's oldest newspaper, founded in 1885, moved in 1949 from its original site on Commerce to 508 Young Street. The five-story modern building, designed by George Dahl, was necessary for housing a new set of 650-ton presses that were almost three stories tall. The newspaper's editors and reporters continue to operate today from this facility, though the paper is now printed at a plant in Plano.

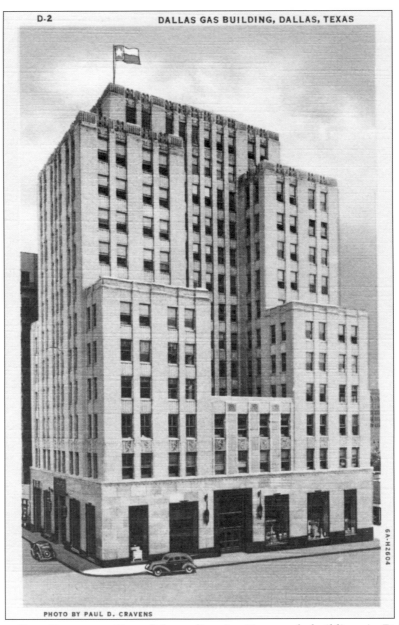

PHOTO BY PAUL D. CRAVENS

LONE STAR GAS COMPANY. One of the earliest Art Deco–style buildings in Dallas arrived on the scene in 1931 with the construction of the Lone Star Gas Building at 301 Harwood Street. The Dallas architectural team of Otto Lang and Frank Witchell designed this 12-story, cream-colored masonry building to adjoin an earlier Sullivanesque-style building they had designed for the Dallas Gas Company. Extending the polished granite base of the older office building to the 1931 building, Lang and Witchell designed a U-shaped structure with elaborate light fixtures that adorn the entrances. Adding character are decorative spandrel panels. The panels found in the building's tower exhibit geometric shapes; those at the base depict human figures. Over the years, the former Lone Star Gas Company underwent name changes and a company buyout. By 2004, the building was owned by Atmos Energy. The following year, Atmos Energy donated this building, along with others on the block, to the City of Dallas.

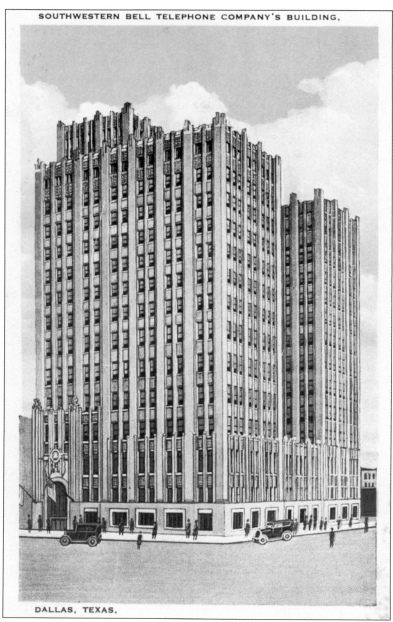

SOUTHWESTERN BELL TELEPHONE COMPANY'S BUILDING.

DALLAS, TEXAS.

SOUTHWESTERN BELL TELEPHONE COMPANY. This Art Deco–style building, at 308 South Akard Street, provided space for the burgeoning Southwestern Bell Telephone Company to consolidate its Dallas offices in 1929. Prominent Dallas architects Lang and Witchell designed a pale yellow building with white stone trim. Above the keystone rests the company's universal symbol, a large stone bell. Dallas's first telephone exchange opened on June 1, 1881, with 40 subscribers. There were several competing telephone companies before 1925 when Southwestern Bell became the sole provider. The number of telephones in use quickly soared from 30,000 in 1922 to 200,000 in 1949. Serving customers in five states, Southwestern Bell was one of seven "Baby Bells" to emerge from the breakup of AT&T in 1984. Today the building anchors a complex of buildings between Commerce and Jackson Streets that provides offices for the modern AT&T.

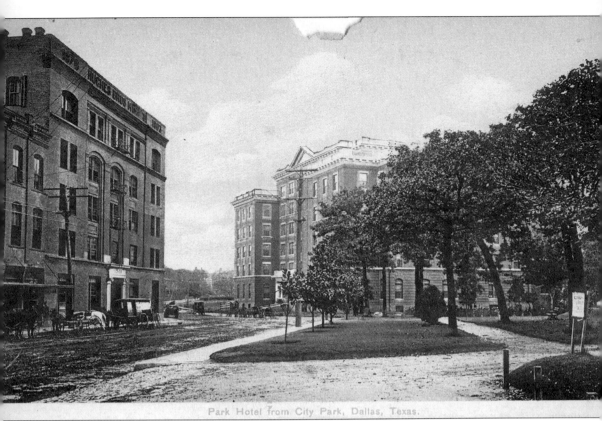

Park Hotel from City Park, Dallas, Texas.

PARK HOTEL. Designed by local architect Henry Silven and constructed at a cost of $17,500, the building was named the Majestic Hotel when it opened in 1905. Lack of business sent the hotel into receivership in 1906, and it was purchased by F. W. Boedecker who changed the name to the Park Hotel. It became a residential hotel, but since its rooms had no kitchens, guests were provided three meals a day that were served in the dining room, which overlooked City Park. With an electric elevator, steam heat, electric lights, private baths, and telephone connections, the Park Hotel was a luxurious substitute for a private home. The hotel changed hands again in 1910 and once more in 1932. The Ambassador Corporation, the new owners, remodeled the building's exterior, covering the brick with white stucco and adding a red tile roof typical of the Spanish Colonial Revival style. They changed the name to The Ambassador Hotel and welcomed a capacity crowd to the rooms, suites, and apartments during the Texas Centennial in 1936.

HILTON HOTEL. In the mid-1920s, Conrad Hilton, a Texas hotel operator, was beginning to make his name in the hotel business with small- and medium-sized hotels. This was his first high-rise hotel and the first where he put the Hilton name. The distinguished local architectural firm of Lang and Witchell designed it with symmetrical towers and Beaux Arts influences. Today it is a boutique hotel.

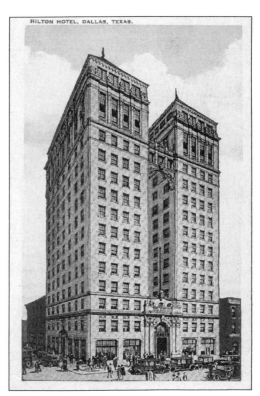

HILTON HOTEL, DALLAS, TEXAS.

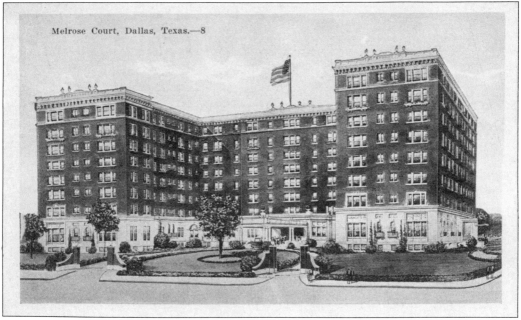

Melrose Court, Dallas, Texas.—8

MELROSE HOTEL. Originally called Melrose Court and located at Oak Lawn and Cedar Springs, this eight-story building was an apartment hotel designed by Dallas architect C. D. Hill. It had 149 oversized rooms that could function either as overnight accommodations or as a place to live until more space was needed. After a slow start, Melrose thrived as a neighborhood hotel. Restored in 1983 and 2003, the hotel continues to flourish.

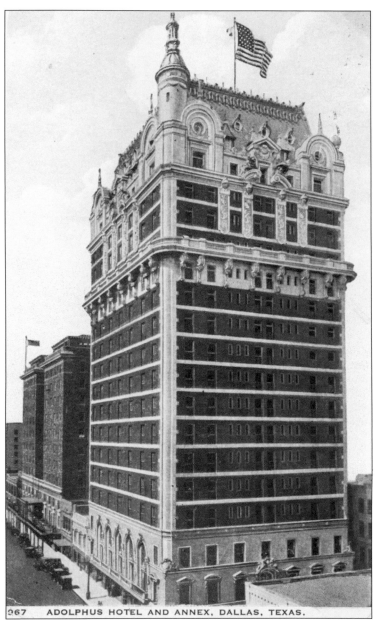

267 ADOLPHUS HOTEL AND ANNEX, DALLAS, TEXAS.

ADOLPHUS HOTEL AND ANNEX. St. Louis brewing magnate Adolphus Busch built this opulent baroque hotel on the site of the old Dallas City Hall in 1912 at a cost of over $1.5 million. Architect Tom Barnett was inspired by the Plaza Hotel in New York and the Blackstone in Chicago. The Annex, called the "Junior Adolphus," opened in 1918 and was 50 feet down the street from the main hotel. Later additions and remodeling pulled the facade together. The Century Room, the hotel's legendary nightclub, opened in 1936 to entertain Texas Centennial visitors and remained a favorite spot for many years. It featured well-known musicians such as Artie Shaw, Glenn Miller, and Tommy Dorsey. Over the years, the Adolphus has hosted everyone from Babe Ruth to Queen Elizabeth II in its luxurious accommodations. The main entrance was originally on Akard Street but moved to Commerce Street as the hotel expanded down the block. The hotel's current look stems from a $60-million renovation completed in 1981.

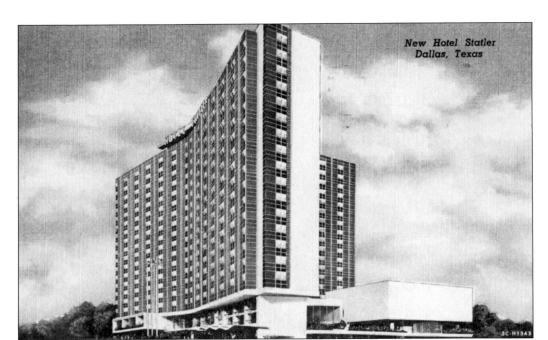

New Hotel Statler
Dallas, Texas

STATLER HILTON HOTEL. Completed in 1956 at a cost of $16 million, the Statler was the first major hotel built in Dallas in nearly three decades and was the largest convention facility built in the South. It stands 19 stories high and included 1,001 guest rooms and a ballroom that could accommodate more than 2,000 people. William Tabler from New York designed the Y-shaped building, which is hailed as the first glass and metal hotel in the nation. The hotel's other structural innovations included a flat-slab structural system, which greatly reduced the number of columns in the hotel's large reception areas, allowing for grand uninterrupted spaces. It also featured an innovative thin-skinned curtain wall construction and was one of the first buildings in the nation to do so. As the largest hotel in the Southwest, the Statler helped attract convention business to Dallas for many years.

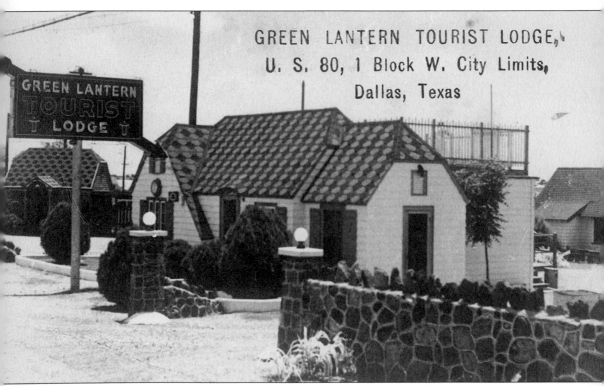

GREEN LANTERN TOURIST LODGE,
U. S. 80, 1 Block W. City Limits,
Dallas, Texas

GREEN LANTERN TOURIST LODGE. Before 1967, U.S. Highway 80 was the main highway connecting Dallas to points east and west. Dozens of motor inns (differing from hotels in that they catered to automobile travelers, with stand-alone or duplex sleeping accommodations and adjacent parking) sprang up. The Green Lantern Tourist Lodge opened about 1936 on the western edge of Dallas. It was well positioned to attract tourists who didn't want to drive to the next town (this was a time when the towns in Dallas and Tarrant Counties did not touch at their city limits) before stopping for the night. The motel was operated by Pearl Marie Henslee, daughter of La Reunion colonist Gustave Santerre. Although the main building of the Green Lantern Tourist Lodge at 3712 West Davis Street is now gone, the small bedroom cottages that surrounded it still remain. The motel has operated since about 1953 as the Shangrila Motel.

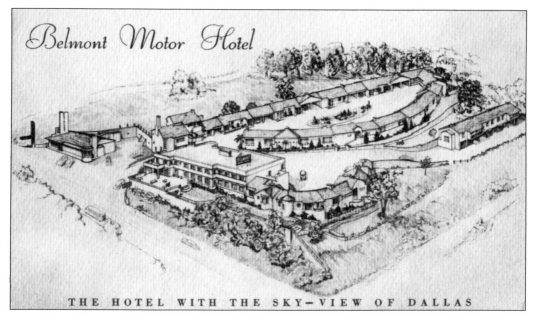

THE HOTEL WITH THE SKY—VIEW OF DALLAS

BELMONT MOTOR HOTEL. The Belmont is architect Charles Dilbeck's phoenix risen from the ashes of decline. Perched on a limestone ledge at the corner of Fort Worth (Highway 80) and Sylvan Avenues, the Belmont opened in 1947 as one of Texas's first luxury motor hotels. It was a true traveler's oasis with a pool, restaurant, and a stunning view of the Dallas skyline. Only a decade later, traffic began to shift to the nearby DFW Turnpike. As the neighborhood around it declined, so did the Belmont. Developer Monte Anderson spent several years cutting the Belmont out of the kudzu that had enveloped it and restoring the facility, which reopened in 2005. That redevelopment has had a strong, positive impact on the surrounding neighborhood. (Below, courtesy Errol Miller.)

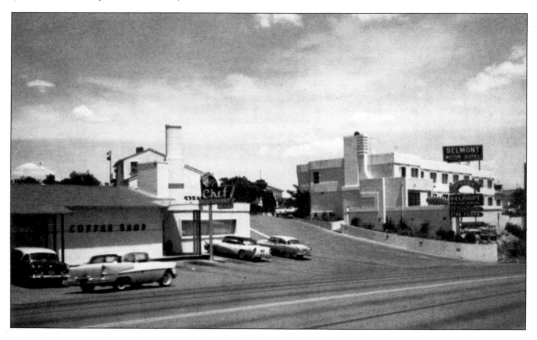

STONELEIGH HOTEL. Built in 1923, the Stoneleigh Court was Dallas's first luxury residential hotel. This handsome stone edifice, designed by F. J. Woerner, featured the first air-conditioned guest rooms in Dallas. In 1938, the 11th and 12th floors were converted into an Art Deco penthouse for Col. Harry Stewart. In 2008, the Stoneleigh was brought back to its original splendor and reopened as a luxury hotel and spa. (Courtesy the Stoneleigh Hotel.)

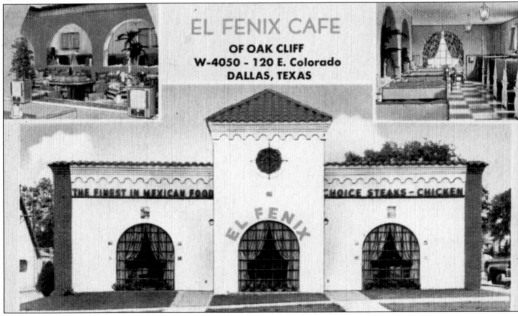

EL FENIX, OAK CLIFF. In 1916, Miguel Martinez and his wife, Faustina, opened a cafe across the street from their home in the heart of Dallas's "Little Mexico." In 1918, the Martinezes renamed their family restaurant El Fenix after the mythological phoenix, a bird representing strength and renewal, and began offering a cuisine that came to be known as Tex-Mex. The Oak Cliff restaurant on Colorado Boulevard opened in 1948.

Two

RESIDENCES

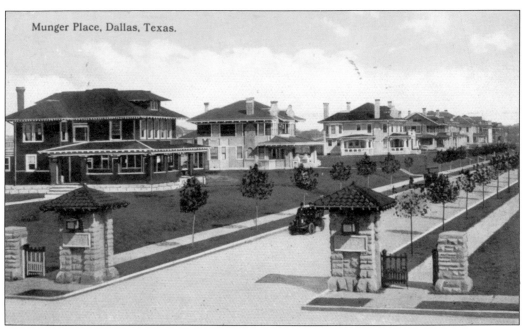

Munger Place, Dallas, Texas.

MUNGER PLACE GATES. Munger Place, established in 1905 by cotton gin manufacturer Robert S. Munger, was a deed-restricted planned residential development with specifications for the cost and size of homes as well as how far back they were set from the street. The Munger Place gates defined the neighborhood for both residents and visitors but were unfortunately demolished during the 1950s as a traffic hazard. (Courtesy Errol Miller.)

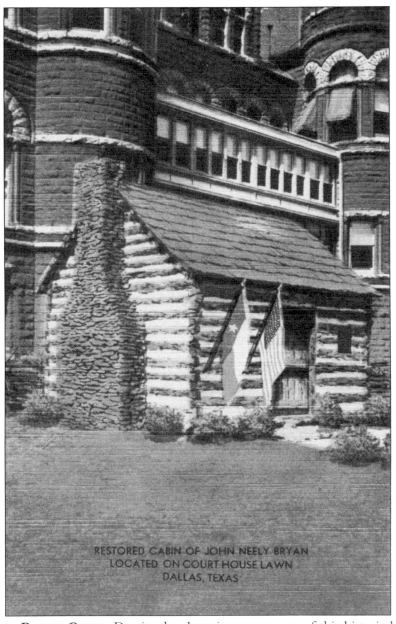

RESTORED CABIN OF JOHN NEELY BRYAN
LOCATED ON COURT HOUSE LAWN
DALLAS, TEXAS

JOHN NEELY BRYAN CABIN. Despite the charming appearance of this historic log cabin, it may not be the one that housed Dallas founder John Neely Bryan. Once located on the grounds of Buckner Orphans' Home, this cabin may actually have belonged to an earlier landowner in that area rather than to Bryan. R. C. Buckner, who found the cabin on the land he purchased for the orphans's home, believed the cabin to be Bryan's home and, in 1908, moved it into the basement of one of the Buckner buildings where he marked it as both Dallas's first home and courthouse. In 1935, Buckner donated the cabin to Dallas County, and it was rebuilt and restored on the lawn of the Old Red Courthouse. It opened in 1936 as part of the Texas Centennial celebration in Dallas. Whether or not the cabin has ties to Bryan, it is, nonetheless, a nostalgic reminder of Dallas's past and the sort of dwelling its founder might have occupied. The cabin currently sits on a plaza in front of the Records Building.

Series 1194 A. A Residence in Dallas, Texas. Davidson Brothers.

BELO MANSION. *Dallas Morning News* magnate Alfred H. Belo built his mansion on Ross Avenue, a street bordering the business district filled with similar homes. This 1908 postcard depicts the Neoclassical portico added in 1900. The home had several uses over the years, including the funeral home where Clyde Barrow's body was prepared for burial. Today it is the sole residential survivor in the arts district and houses the Dallas Bar Association.

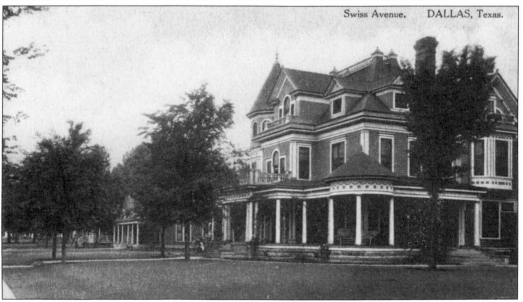

Swiss Avenue. DALLAS, Texas.

SWISS AVENUE. Swiss native and Dallas mayor Benjamin Long brought a group of Swiss settlers to Dallas in 1870 that gave this major residential street east of town its name. The portion of Swiss Avenue in the Munger Place development, still home to many notable early-20th-century mansions, was the city's first National Register Historic District, a designation that helped spur its revitalization.

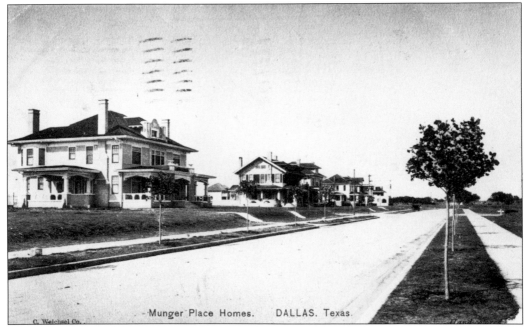

Munger Place Homes. DALLAS. Texas.

MUNGER PLACE. Boulevards landscaped with trees (admittedly quite small in this street scene) and sidewalks let viewers know that Munger Place was an exclusive neighborhood. Many Dallas business and civic leaders made their homes here during the early years of the 20th century. The neighborhood has a wide variety of architectural styles ranging from Craftsman bungalows and Prairie School to historic Tudor, Colonial, and Neoclassical Revival styles. The landscaping, inspired by the City Beautiful movement, which held that creating a beautiful and tranquil place to live led to a better life, also extended to individual yards. Features such as arbors, fountains, and lawn furniture created a pleasant living space outdoors.

A MUNGER-PLACE HOME, DALLAS, TEXAS

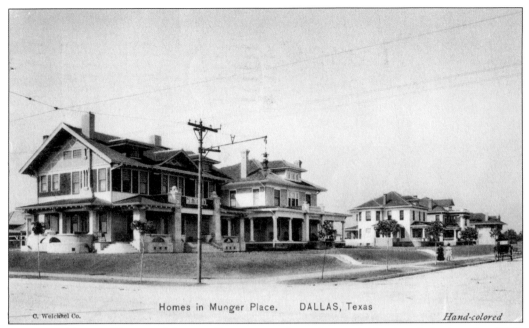

Homes in Munger Place. DALLAS, Texas

C. Weichsel Co. Hand-colored

MUNGER PLACE HOMES. Munger Place was a showplace neighborhood during the 1910s and 1920s. Streetcars provided easy access to downtown jobs and shopping, and the maturing trees shaded homes built before air-conditioning was available. During the Great Depression of the 1930s and World War II, some of the large homes in Munger Place were subdivided for apartments. Following the war, many families moved to new homes in the suburbs. A turnaround began in the 1970s when historic designations protected the neighborhood, prompting its revitalization. Today residents value the design and craftsmanship of these homes as well as their convenient location. (Below, courtesy DPL.)

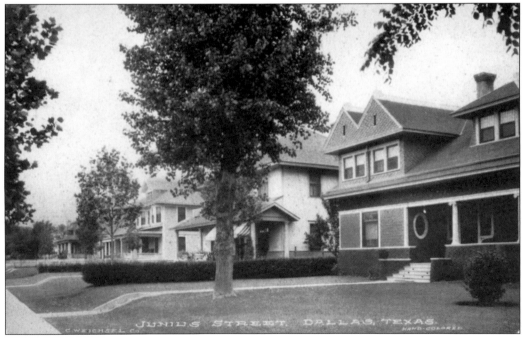

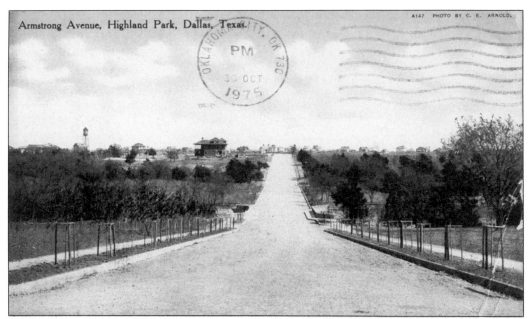

ARMSTRONG AVENUE. This wide boulevard was named for John S. Armstrong, who in 1907 invested the proceeds from his grocery and meat-packing businesses in property north of Dallas and began developing Highland Park, a fine residential suburb advertised as being "10 degrees cooler" than the nearby city. The boulevard was designed to preserve a historic pecan tree planted by pioneer John Cole after the Civil War.

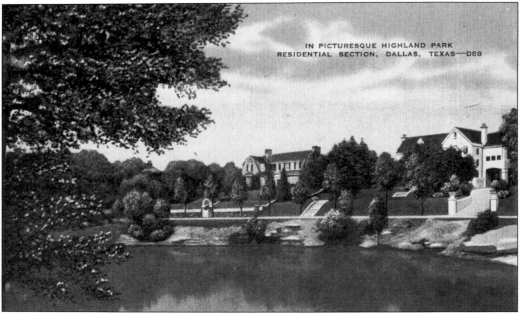

IN PICTURESQUE HIGHLAND PARK
RESIDENTIAL SECTION, DALLAS, TEXAS—D88

HIGHLAND PARK HOMES. Highland Park's founder, John Armstrong, and his son-in-law Hugh Prather visited California and were impressed by the work of Wilbur David Cook, who was designing early Beverly Hills. They hired Cook to lay out the early portions of their development, incorporating views of winding creeks and Exall Lake. Lakeside Drive, shown in this card, remains a scenic centerpiece of the residential community.

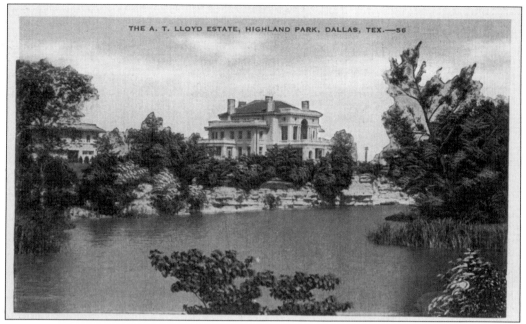

THE A. T. LLOYD ESTATE, HIGHLAND PARK, DALLAS, TEX.—56

LLOYD ESTATE. One of the grandest homes constructed during the early years, even by Highland Park standards, was the residence designed for Rose and A. T. Lloyd by distinguished Dallas architect Herbert Greene. The lavish Italianate dwelling sits on a 6-acre site overlooking Turtle Creek and was described in the *Dallas Morning News* in 1915 as the "most expensive residence site ever sold in Dallas."

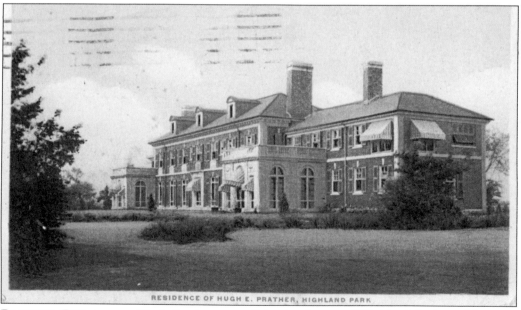

RESIDENCE OF HUGH E. PRATHER, HIGHLAND PARK

PRATHER RESIDENCE. Hugh Prather, one of the developers of Highland Park, and his wife brought architect Anton Korn from New York in 1917 to design their home on one of the extra-large lots overlooking Exall Lake. Developer Harlan Crow, who purchased the house in 1985, has added two wings, one of which houses his extensive library. (Courtesy Old Red Museum of Dallas County History and Culture.)

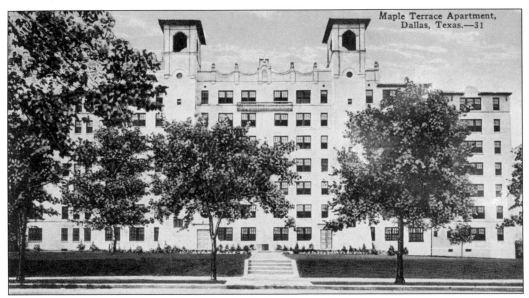

MAPLE TERRACE APARTMENTS. British architect Sir Alfred Bossom designed this 1924–1925 building on Maple Avenue in a rich Spanish Colonial Revival style, arguing that typical apartment blocks were ugly. Early marketing described a place "where apartments are real homes" and noted that the watchtowers offered a view of "the entire peaceful city of Dallas." Each floor featured the same flexible plan that allowed one-room apartments to be combined with larger ones.

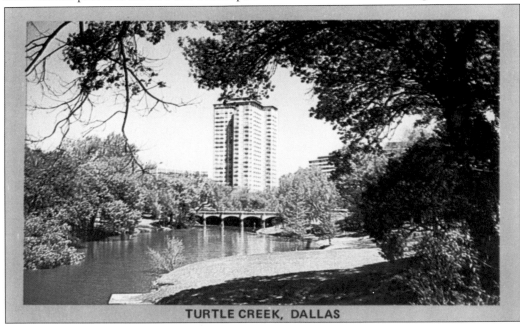

TURTLE CREEK, DALLAS

TURTLE CREEK BOULEVARD. Designed in 1957 by architect Howard Meyer, 3525 Turtle Creek was Dallas's first luxury high-rise apartment house. Meyer combined Mexican brick, textured concrete, and distinctive sun screens to create a building that is now considered an icon of Mid-Century Modern architecture. Famous residents have included actress Greer Garson, who occupied the penthouse with her oilman husband, Buddy Fogelson. (Courtesy Old Red Museum of Dallas County History and Culture.)

CLIFF TOWERS HOTEL. Developer Charles Mangold completed this building, across from scenic Lake Cliff Park, in 1932 as the Great Depression deepened. His original vision for an exclusive residential hotel shifted slightly, and the tower was rented as apartments for many years before being converted into a nursing home in the 1960s. Restored in 2006, Lake Cliff Tower is now a condominium development. (Courtesy Errol Miller.)

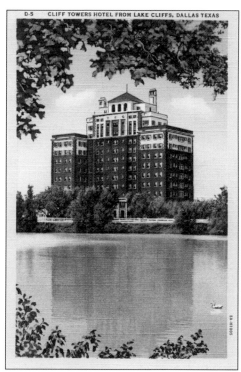

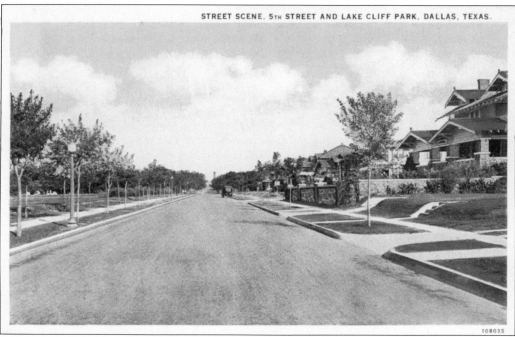

FIFTH STREET AND LAKE CLIFF PARK. Few homes were built around Lake Cliff while the casino and amusement rides operated, but development at the southern end of this Oak Cliff park accelerated after the City of Dallas acquired the park in 1914. Homes on East Fifth Street face the lake and park, offering scenic views and easy access to recreation. The house on the right in the foreground belonged to noted Dallas photographer Frank Rogers.

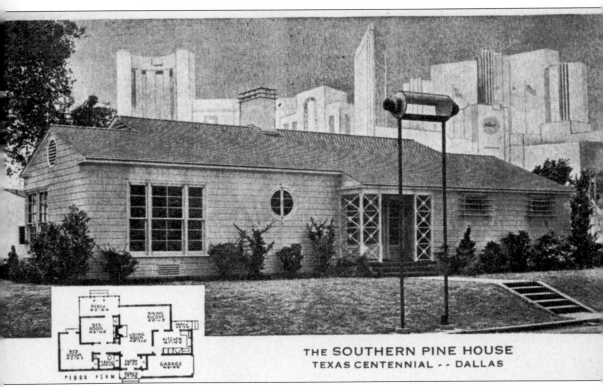

THE **SOUTHERN PINE HOUSE**
TEXAS CENTENNIAL -- DALLAS

SOUTHERN PINE HOUSE. During the 1936 Texas Centennial Exposition, Depression-ravaged corporations and associations showcased their products for the public. The Southern Pine Association promoted the benefits of their quality (yellow) pine in home construction using a feature-filled model home that Texas Centennial visitors could tour. The house has a very modern appearance, a Minimal Traditional style that did not use decorative detailing from historic designs. Pinewood held center stage—even the interior paneling was carefully matched unpainted pine that allowed the beauty of the wood grain to shine through. The home furnishings and decorative accents were provided by the Sanger Brothers department store. Giveaway postcards encouraged prospective home builders to use Southern Pine products in their own homes. In 1938, the model home was moved from Fair Park to a nearby neighborhood, where it still serves as a residence.

Three

RECREATION AND ENTERTAINMENT

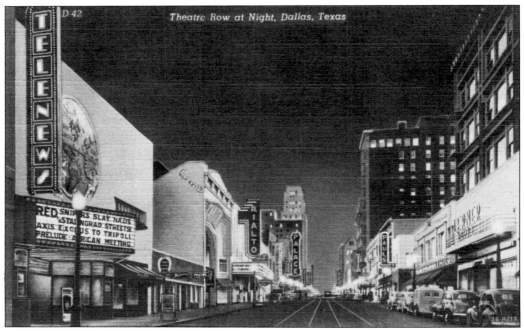

THEATER ROW AT NIGHT. The first screened shows in Dallas were a series of short subjects shown at the Dallas Opera House in 1897. By the second decade of the 20th century, Elm Street was home to Dallas's "Theater Row," with a long string of vaudeville and motion picture houses constructed during the second decade of the 20th century and into the 1920s. There were as many as four theaters per block, with names such as Palace, Empress, Queen, and Star. Some houses initially combined vaudeville and moving pictures in their shows, but eventually, celluloid reigned supreme. Theaters ran the gamut from first-run houses to newsreel theaters, which were especially popular during World War II. Fans abandoned the single-screen downtown movie palaces for suburban multiplexes during the 1960s, and by the early 1970s, most of Elm Street's fabled theaters had been demolished. The Majestic, almost invisible at the eastern end of this row, is the only survivor.

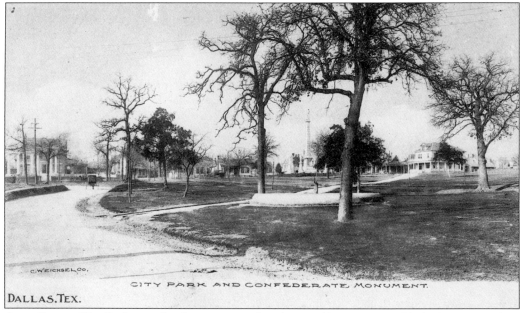

CITY PARK. City Park was the first municipal park in Dallas. It was established in 1876 when Dallas officials agreed to exempt Col. J. J. Eakins from taxes on all properties he owned for four years in exchange for his 10 acres adjacent to Browder Springs. Other purchases of adjacent land created a 19-acre park by 1885. The city began extensive landscaping in 1886, including several bridges over Mill Creek and one of its branches that meandered through the park. Roads and footpaths were installed among the trees, and five electric arc lamps provided light in the evening. In 1896, the Confederate Memorial was placed in the park. The memorial moved in 1961 to Pioneer Cemetery, adjacent to the Dallas Convention Center, when freeway construction removed 5 acres from the northern end of the park.

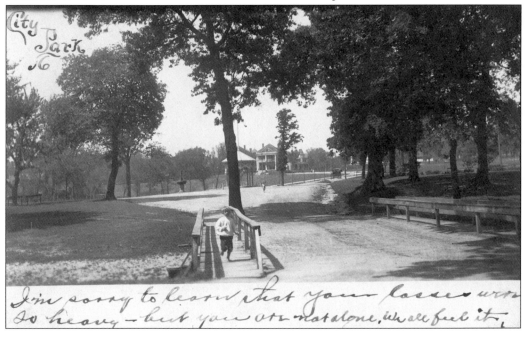

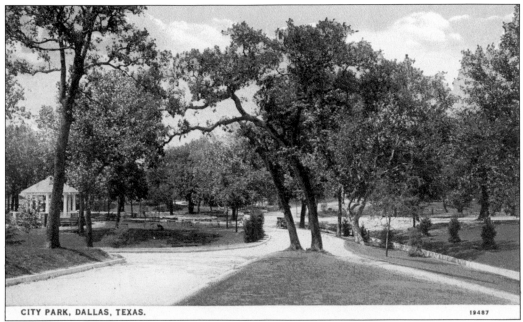

CITY PARK, DALLAS, TEXAS. 19487

CITY PARK. With a conservatory built in 1890 and a bandstand constructed in 1898, City Park became a popular site for families to picnic and enjoy flower displays. Tennis courts were installed in 1917, and a full-sized swimming pool and lighted softball diamond were added in the 1940s. By the 1960s, City Park's ample space near downtown made it an attractive site for development of a different sort of park. In 1967, the city authorized the Dallas County Heritage Society (DCHS) to move Millermore, one of the largest remaining antebellum mansions in Dallas, to City Park after the house was threatened with destruction. This was the beginning of a project spearheaded by the DCHS to add other endangered buildings of historic value to the park and to develop a living history museum, which is now known as Dallas Heritage Village.

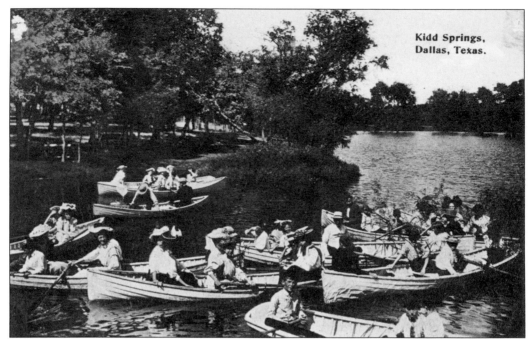

Kidd Springs,
Dallas, Texas.

KIDD SPRINGS PARK. Kidd Springs Park, off of Tyler Street in Oak Cliff, was initially home to the exclusive Kidd Springs Boating and Fishing Club organized in 1895. Members enjoyed boating, dancing, bowling, picnics, and on at least one occasion watching a tightrope walker. By 1912, the 25-acre park was open to the public. In the 1930s, a swimming pool (replaced in 1958) offered bathers a respite from the summer heat with waterslides and diving boards. Today's park owes its look to a 1970s campaign that expanded the grounds to 31 acres. Kidd Springs Park is still a popular gathering spot for picnics, swimming, baseball, tennis, and simple relaxation. (Below, courtesy Errol Miller.)

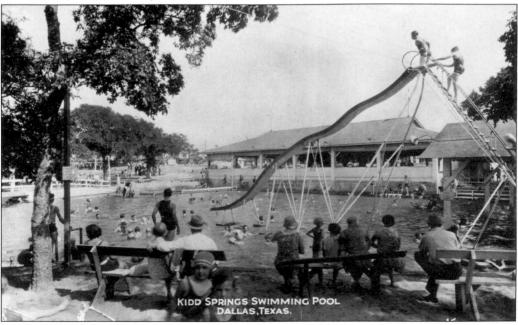

KIDD SPRINGS SWIMMING POOL
DALLAS, TEXAS.

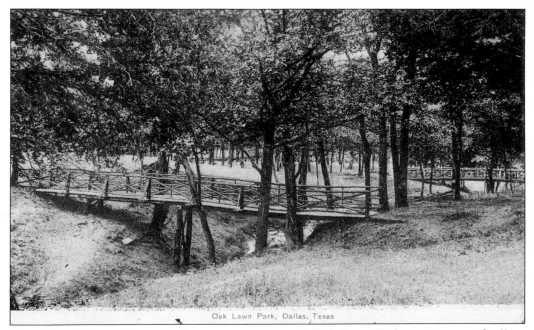

Oak Lawn Park, Dallas, Texas

OAK LAWN PARK. A street railway company created Oak Lawn Park on 17 acres of rolling hillside overlooking Turtle Creek in the late 19th century as an attraction to surrounding residential developments. The city purchased it as a municipal park in 1909 and built tennis courts, a softball diamond, playground equipment, and other amenities. (Courtesy Old Red Museum of Dallas County History and Culture.)

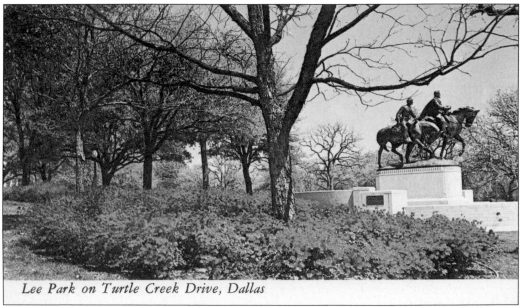

Lee Park on Turtle Creek Drive, Dallas

LEE PARK. During his visit to the Texas Centennial Exposition in Dallas in June 1936, Pres. Franklin Roosevelt unveiled a statue of Confederate general Robert E. Lee at the former Oak Lawn Park, which was renamed Lee Park. A replica of Lee's Virginia mansion, known as Arlington Hall, was completed in 1939, along with other improvements constructed in cooperation with the Works Progress Administration, such as bridges and picnic tables.

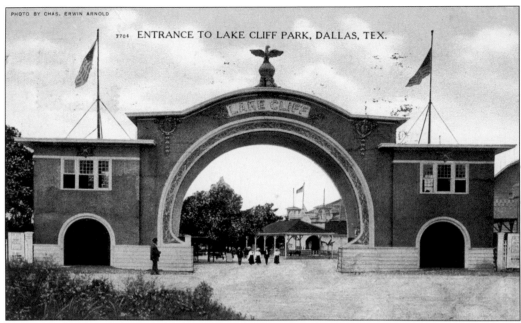

7704 ENTRANCE TO LAKE CLIFF PARK, DALLAS, TEX.

LAKE CLIFF PARK. For a brief period, Lake Cliff Park, in Oak Cliff, was the place to go for entertainment. Business leader Charles Mangold and investors spent nearly $1 million to build a cultural center and amusement park like no other in Texas. Inspired by the museums and circuses of Europe, Mangold brought a magical world of rides and entertainment that included bowling, swimming, tennis, baseball, balloon races, dancing, and a host of other activities. In spite of the excitement that accompanied its opening, attendance was never high enough to sustain the stupendous wonderland. In 1914, Mangold sold the property to the City of Dallas for use as a public park, and many of the buildings were dismantled. Lake Cliff remains a scenic spot, though on a much quieter scale. (Above, courtesy Errol Miller.)

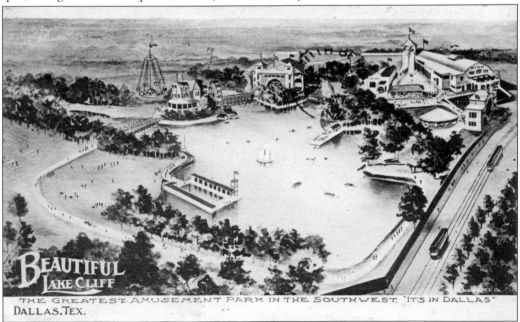

BEAUTIFUL LAKE CLIFF

THE GREATEST AMUSEMENT PARK IN THE SOUTHWEST. "IT'S IN DALLAS" DALLAS, TEX.

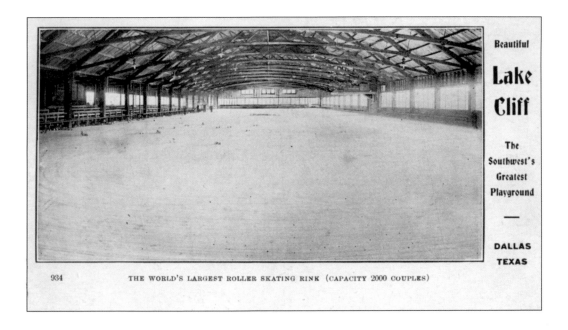

934 THE WORLD'S LARGEST ROLLER SKATING RINK (CAPACITY 2000 COUPLES)

SKATING RINK AND CONCERT, LAKE CLIFF PARK. Every aspect of Lake Cliff Park was built on a grand scale, including the open-air skating rink. Designed to accommodate 2,000 skating couples, and with a seating capacity of 2,500, the rink featured a live band, to whose music skaters would glide to across a white maple floor. Dallas music lovers were not confined to the sounds emanating from the skating rink, however. Lake Cliff Park offered a variety of venues for listening pleasure. Popular attractions included the opera house as well as outdoor concerts, where bands often played on Sunday afternoons. (Below, courtesy Errol Miller.)

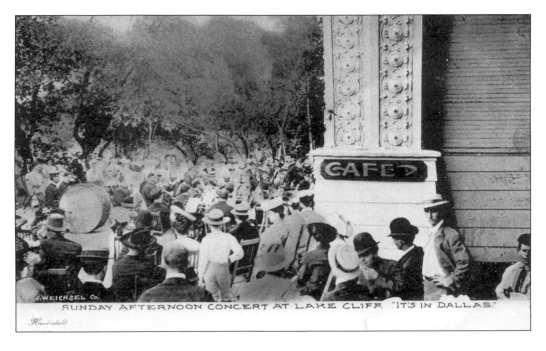

C. WEICHSEL CO.

SUNDAY AFTERNOON CONCERT AT LAKE CLIFF. "IT'S IN DALLAS."

Hand-colored

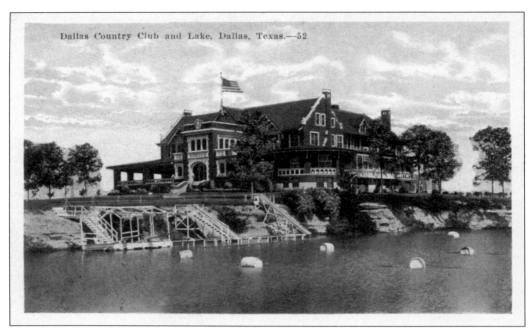

Dallas Country Club and Lake, Dallas, Texas.—52

DALLAS COUNTY CLUB. The state's first country club was organized in 1896 in a former cow pasture in Oak Lawn. Highland Park's developers enticed the club to move there, where it would straddle the banks of Turtle Creek. Their ploy succeeded and 172 out of 180 lots surrounding the club were sold before the golf course was finished in 1912. This Elizabethan clubhouse burned and was replaced with a modern one in the 1950s. (Courtesy Andy Hanson.)

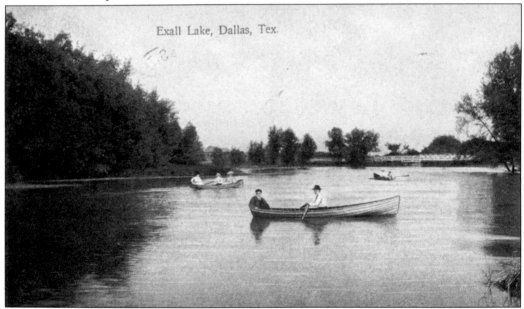

Exall Lake, Dallas, Tex.

EXALL LAKE BOATERS. Henry Exall acquired property along Turtle Creek in 1890. He damned part of it to form Exall Lake and attempted to develop a fine residential suburb to be called Philadelphia Place. An economic recession stopped the project, which resumed under new owners in 1907 as Highland Park. But Exall Lake remained a popular destination for picnickers and boaters.

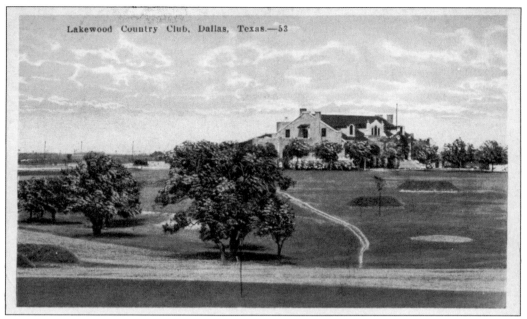

LAKEWOOD COUNTRY CLUB. When Dallas businessmen in 1914 deemed the city in need of a second 18-hole golf course, a natural selection was the East Dallas picnic grounds that overlooked White Rock reservoir. The Spanish Eclectic clubhouse, designed by Charles D. Hill, included second-story balconies for observing tournaments. Lakewood Country Club at 6430 Gaston Avenue remains in operation and is known for its beauty and elegance.

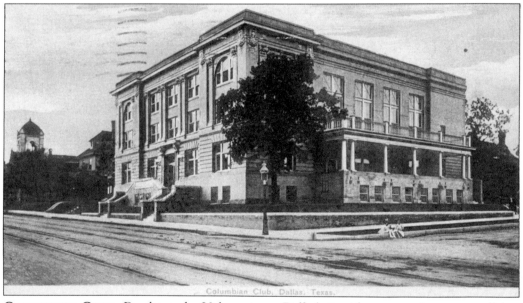

COLUMBIAN CLUB. By the early 20th century, Dallas's Jewish community was small but prominent, as a majority were the owners of many department stores and retail establishments. The Columbian Club was organized in 1905 to present Jewish debutantes. This clubhouse on South Ervay Street served as a social center for the growing Jewish community for several decades until a country club with a swimming pool, tennis courts, and other amenities was constructed in far northern Dallas.

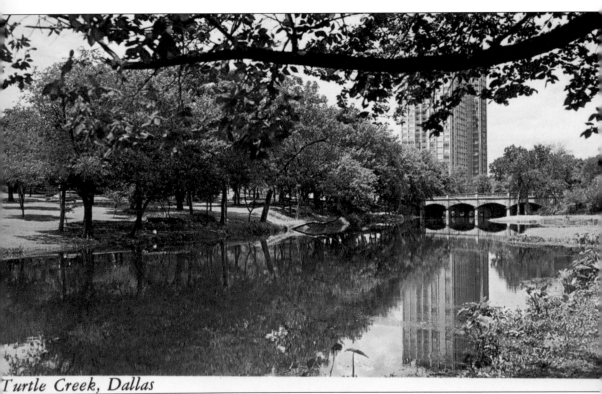

Turtle Creek, Dallas

TURTLE CREEK PARKWAY. Dallasites have long admired the scenic creek that meanders southward from Highland Park to the Trinity River. Known as Turtle Creek Parkway, today it is a system of parks and green space first proposed by Kansas City landscape architect George Kessler in 1910. The landscaped parkway evolved over the years and is today one of the crown jewels of the city's park system.

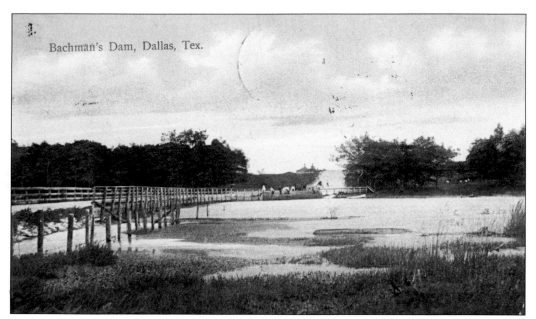

Bachman's Dam, Dallas, Tex.

BACHMAN'S DAM. Contending with an increased demand for water, city leaders resolved to dam Bachman Creek during the early 1900s, creating a reservoir to hold one billion gallons of water. Ironically, work on the dam came to a halt in 1901 when dirt became too dry to pack down. Heavy rains in 1902, however, allowed workers to finish and the dam soon filled to capacity.

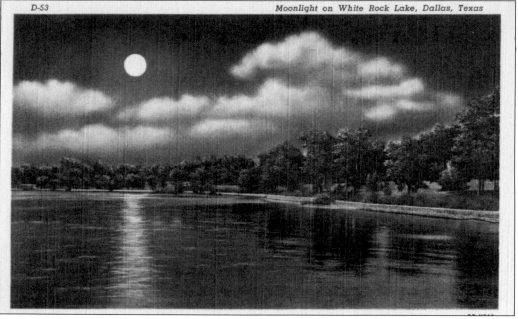

D-53 Moonlight on White Rock Lake, Dallas, Texas

WHITE ROCK LAKE. With Dallas in need of more potable water, White Rock Creek was dammed in 1911, creating a reservoir where a dairy farm once stood. Dallasites soon discovered that the area was ideal for outdoor activities, and improvements were made. Structures built by the Civilian Conservation Corps and the Works Progress Administration remain at this scenic oasis in the midst of urban development.

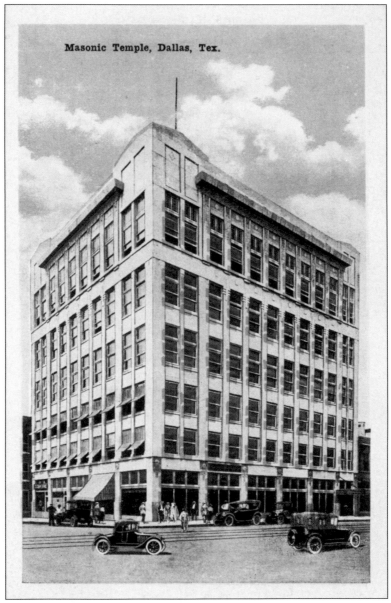

Masonic Temple, Dallas, Tex.

OLD MASONIC TEMPLE (WESTERN UNION). Lang and Witchell designed this six-story tower for local Masons. Although the contract was let in 1912, financial difficulties prevented the building's completion until 1915, when the Masons took out a $70,000 loan to finance the finishing work. Located at the corner of Main and Harwood Streets, the fireproof building was constructed of concrete and reinforced steel. The first three floors were rented for mercantile purposes, and the top three floors were reserved for Masonic meetings and banquets. The most impressive space in the building was the auditorium on the sixth floor, where dances and banquets were held. In 1919, the Masons decided to lease the entire building to Western Union and move to another space. The Masons retained ownership, and the rent gave them a dependable income stream without the burden of maintaining the large structure. Now restored, the building houses the Dallas Arts Center with office space and a restaurant. The ballroom on the sixth floor is rented for special occasions.

SCOTTISH RITE CATHEDRAL. The distinguished Dallas architect Herbert Greene designed this Neoclassical temple for the Scottish Rite Order of Masons at Harwood and Young Streets in 1906. Costing $300,000, exclusive of furnishings, the cathedral was not completed and dedicated until 1913. With meeting and banquet rooms and library and parlor, the cathedral is still in active use.

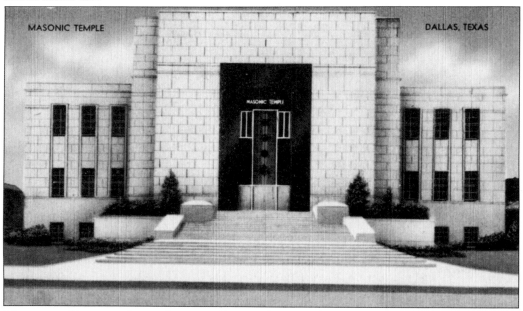

MASONIC TEMPLE. Located across Harwood Street from the Scottish Rite Cathedral, the Masonic Temple presents a sharp contrast in architectural style. Designed in 1941 in a Classical Moderne style, it was one of the last downtown buildings constructed prior to World War II. Appropriately for Masons, it is an all–masonry structure and still shared by several Masonic lodges.

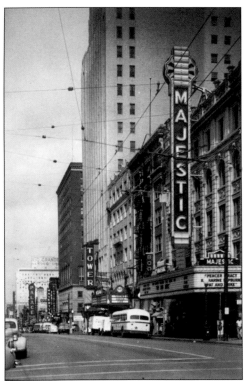

MAJESTIC THEATER. Elm Street's lone surviving theater, the Majestic, was the flagship of Karl Hoblitzelle's Interstate Amusement Company. Designed in 1921 by renowned theatrical architect John Eberson, the 2,400-seat Majestic is a Renaissance Revival masterpiece. The Majestic closed in 1973 as moviegoers abandoned downtown for suburban theaters. It was given to the City of Dallas in 1977 and restored as a performing arts center in 1983. (Courtesy Andy Hanson.)

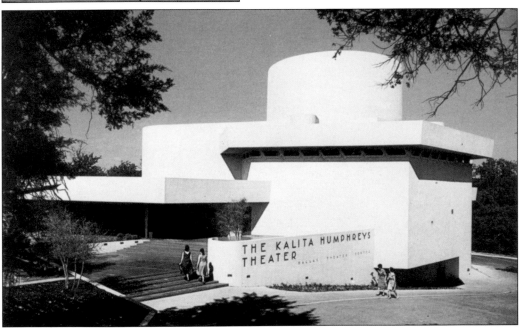

KALITA HUMPHREYS THEATER. The only theater designed by Frank Lloyd Wright stands at 3636 Turtle Creek Boulevard. Completed in 1959 (after his death), Wright's design fit his vision of organic architecture, melding the 400-seat theater with its natural environment. Home to the Dallas Theater Center, the facility was named for a Broadway actress from Texas who died in 1954. Today it continues as an important venue for regional theater.

Four

CIVIC BUILDINGS

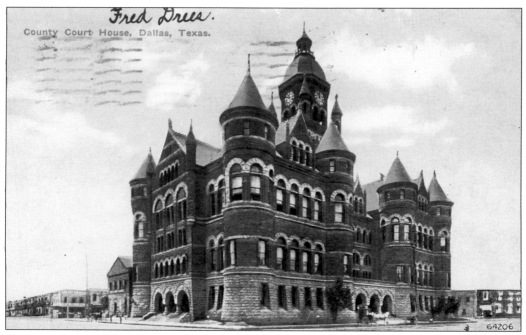

DALLAS COUNTY COURTHOUSE. Lovingly known as "Old Red" because of its red sandstone exterior, the Dallas County Courthouse is a statement about the economic power of the Dallas region in 1892 when it was completed. The sixth courthouse to occupy this site, Old Red has recently been restored, including the replacement of the clock tower removed in 1919. The building how houses the Old Red Museum of Dallas County History and Culture.

FEDERAL RESERVE BANK. For 71 years, this 1921 Neoclassical Revival building at 400 South Akard Street served as the headquarters for the Federal Reserve Bank, Eleventh District. Designed by Chicago architects Graham, Anderson, Probst, and White, the three-story Doric columns gracing the entrance reflect the building's prominence. Decorative steer heads under the cornice, however, are a reminder that this stately financial institution is located in the Southwest.

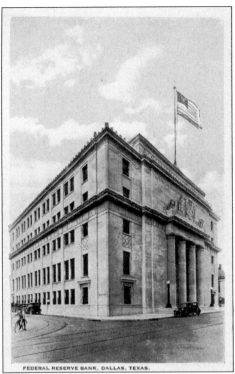

FEDERAL RESERVE BANK, DALLAS, TEXAS.

CITY HALL, DALLAS, TEXAS.

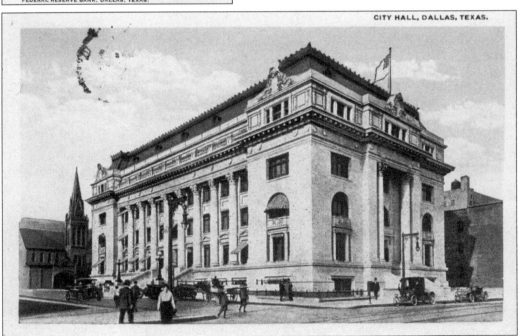

DALLAS MUNICIPAL BUILDING. This classic example of the Beaux Arts style at Main and Harwood Streets was Dallas's fourth city hall. Designed by Charles D. Hill of Dallas, the 1913 building's exterior incorporated Indiana limestone and Texas gray granite. A modern addition in 1956 provided office space for various city departments. Jack Ruby shot Lee Harvey Oswald in the basement entrance of the municipal building on November 24, 1963.

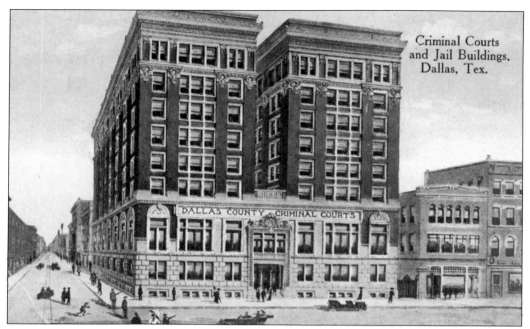

DALLAS COUNTY CRIMINAL COURTS. H. A. Overbeck's 1915 Renaissance Revival building at 501 Main Street served as both courthouse and jail. The jail was one of the first in the nation to include amenities—showers, air ventilation, and ice water—designed for the humane treatment of prisoners. In 1964, Jack Ruby was tried in one of the courtrooms for the murder of Lee Harvey Oswald.

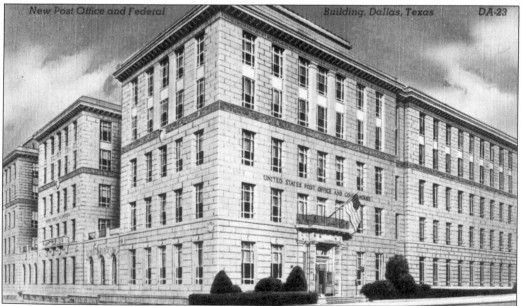

U.S. POST OFFICE AND COURTHOUSE. From pony express to airplane, the history of mail transportation is depicted on terra-cotta tiles beneath the fifth-floor windows of this Italianate Renaissance Revival building, completed in 1930, at 400 North Ervay Street. Although a substantial facility, critics of the day decried its lack of notable artistry. Today it continues to house a post office and has plans for residential lofts.

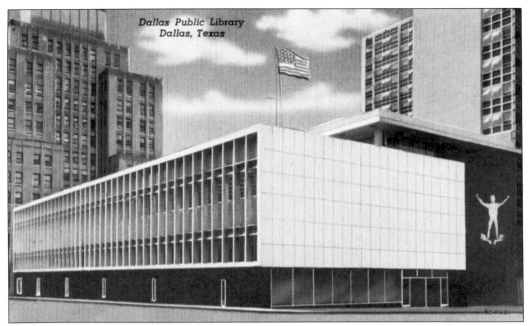

DALLAS PUBLIC LIBRARY. Dallas's 1955 library could not have been more different than the Carnegie Library that it physically replaced at 1954 Commerce Street. Architect George Dahl relied on simple lines, plate glass windows, granite, stone, and aluminum to lend a modern look to this institution. Marshall Fredericks's sculpture of a boy with a book in his hand reaching for the skies graced the outside. The building was vacated in 1982.

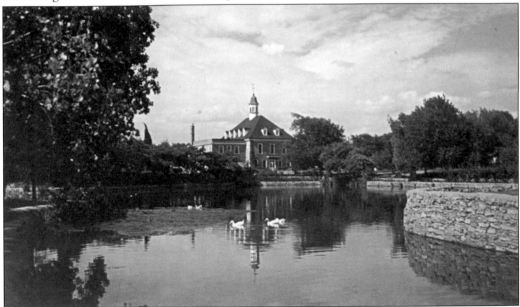

UNIVERSITY PARK CITY HALL. In preparation for remodeling University Park's original 1924 city hall in 1937, architect Grayson Gill visited Williamsburg, Virginia. He then rebuilt and expanded the structure as a faithful but smaller version of the Governor's Palace in Williamsburg, with special sand-molded brick from Mineral Wells, Texas. The city hall has recently been extensively enlarged to accommodate municipal offices.

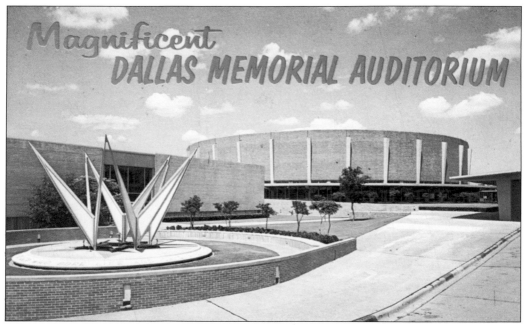

DALLAS MEMORIAL AUDITORIUM. From concept to completion, the Dallas Memorial Auditorium was a full 30 years in the making. Dallas citizens initially passed a $1 million bond in 1927 and again approved funds in the amount of $7 million in 1945. But it was not until 1953 that Mayor Robert L. Thornton announced that a public auditorium was slated for construction. Dallas architect George Dahl designed the three-story domed auditorium to seat 10,000 people. An adjoining exhibition hall and theater were built on the southern side of the auditorium. Dedicated to the Dallasites who sacrificed their lives in war, the Dallas Memorial Auditorium was completed in September 1957. The complex containing Dallas Memorial Auditorium has been expanded four times and is now known as the Dallas Convention Center.

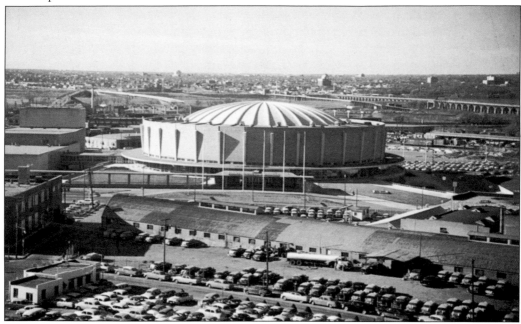

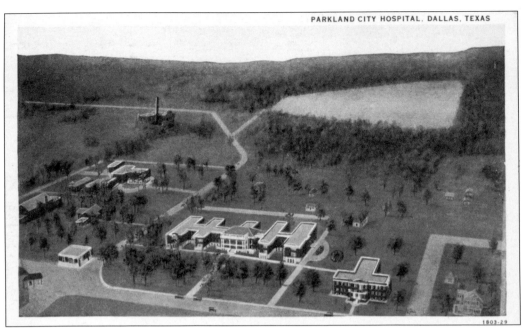

1803-29

PARKLAND HOSPITAL. Dallas County's public hospital began in 1894 in a frame structure on a 17-acre park-like tract at the corner of Maple and Oak Lawn Avenues to address the growing need for sanitary hospital facilities and trained doctors and nurses. A meningitis epidemic in 1911 led to the construction of a new hospital building on the site designed by Hubbell and Greene. The U-shaped brick and terra-cotta building was expanded in 1921, when a nurses' home was built, and again in 1936. By 1941, the hospital was again too small. Instead of expansion, construction of a new Parkland Hospital building on Harry Hines Boulevard began in 1952 and was completed two years later. The old Parkland campus served other hospital uses over the years and in 2008 was renovated as the headquarters for Crow Holdings. (Above, courtesy DPL.)

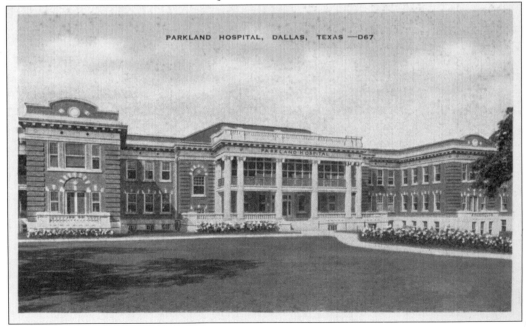

PARKLAND HOSPITAL, DALLAS, TEXAS —D67

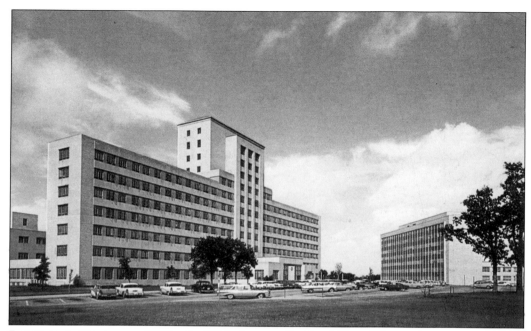

PARKLAND HOSPITAL, 1950s. In 1954, the new Parkland Hospital, 1 mile northwest of the original hospital, was state of the art. The only publicly supported hospital in Dallas County, Parkland is one of the largest teaching hospitals in the United States and delivers more babies than any other in the country. It is, however, best known as the location where President Kennedy, Lee Harvey Oswald, and Jack Ruby all died.

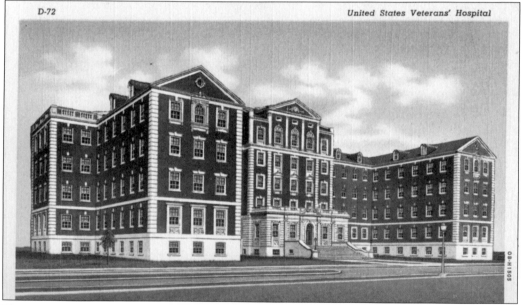

VETERANS' HOSPITAL. In 1938, Dallas was named the site for a new Veterans' Hospital to be built on a 244-acre tract at Lancaster Road and Ledbetter Drive in the community of Lisbon just south of Dallas. The first buildings were completed in July 1940 at a cost of $1.2 million. The complex included a five-story main building with 262 beds, a power plant, and staff offices.

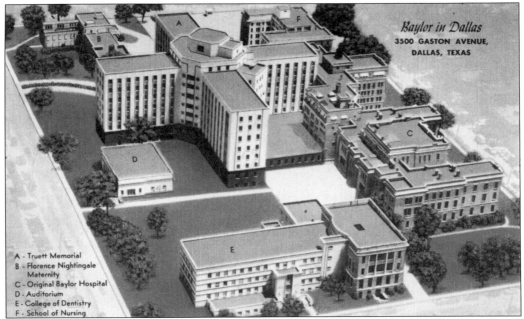

A - Truett Memorial
B - Florence Nightingale
 Maternity
C - Original Baylor Hospital
D - Auditorium
E - College of Dentistry
F - School of Nursing

BAYLOR HOSPITAL. Baylor Hospital was originally built as the Texas Baptist Memorial Sanitarium at the northeastern corner of Junius and Hall Streets. Situated in East Dallas, the property where the original building sat was donated by the Col. C. C. Slaughter family, which was instrumental in its founding. The hospital had begun in 1903 at a residence but soon outgrew the facility. C. W. Bulger was the architect of the Neoclassical building. In 1921, the sanitarium merged with Baylor University to form Baylor Hospital. Eventually, several wings were added to the original building, which served as a hospital until 1969 when it was converted into administrative offices. The hospital is now one of the largest hospital systems in the country.

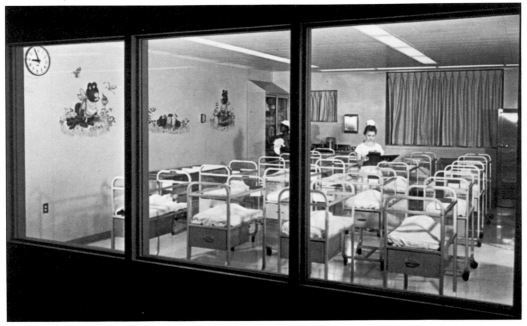

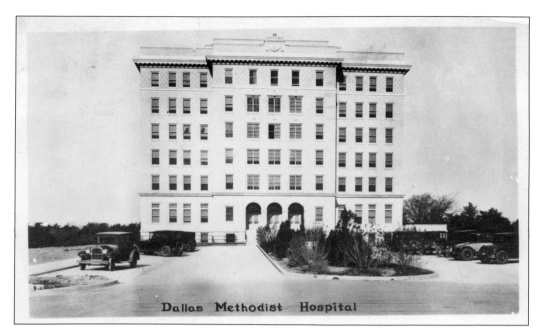

Dallas Methodist Hospital

DALLAS METHODIST HOSPITAL. Dallas Methodist Hospital was founded in 1924 with the support of local Methodist congregations to provide health care in Oak Cliff. At seven stories, the original fireproof building held 100 beds. The first hospital was remodeled and expanded in the 1940s and 1950s. In 1951, a nurses' home was built for nursing students. A new facility was constructed in 1966 that held 420 beds. The system continued to grow throughout the 1970s and 1980s and eventually expanded to become the Methodist Health System. The original hospital building was demolished in 1994 and replaced with a new facility. Other early buildings remain, although remodeled, at the original site. (Above, courtesy Errol Miller.)

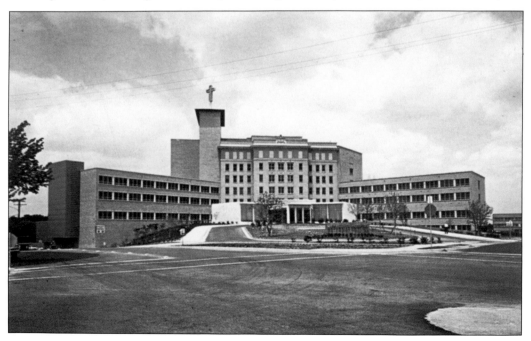

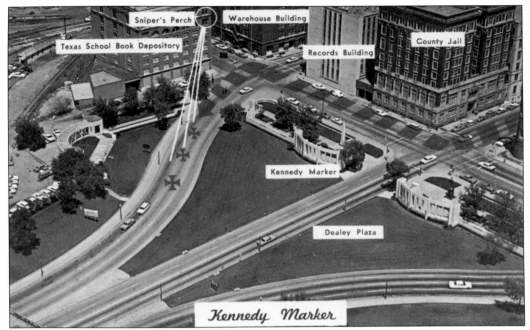

Kennedy Marker

DEALEY PLAZA. Dealey Plaza opened in 1936 as a gateway to the central business district. It was constructed by the Works Progress Administration (WPA) and named after newspaper publisher George Bannerman Dealey. In 1963, Pres. John F. Kennedy was assassinated while his motorcade moved through the plaza. Soon thousands of postcards such as this were produced, indicating the location of the president's limousine and the "sniper's perch" in the Texas School Book Depository.

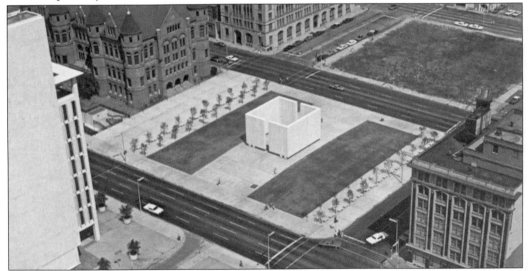

JOHN FITZGERALD KENNEDY MEMORIAL. Following the assassination, Dallas was labeled by many as the "City of Hate." Dallas County residents, determined to memorialize the slain president, formed a committee to develop the appropriate tribute. Committee member and civic leader Stanley Marcus secured noted architect Philip Johnson to design a cenotaph, an open tomb, erected in Kennedy's honor. Seventy-two precast concrete slabs surround a black granite marker inscribed with Kennedy's name.

Five

FAIR PARK

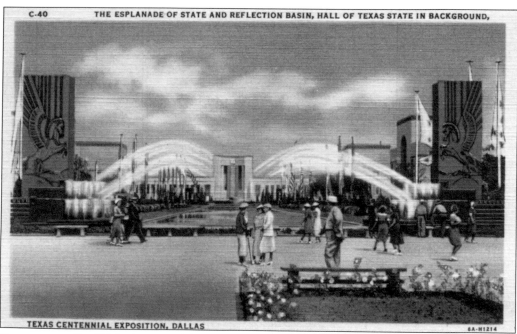

ESPLANADE. In 1936, the state fairgrounds were transformed for the centennial celebration of Texas's independence from Mexico. The Esplanade was the centennial's gateway and was inspired by the Court of Honor at the 1893 Chicago Columbian Exposition and made to reflect George Kessler's 1906 axial landscape design. French sculptor Pierre Boudelle's Pegasus pylons flank the entrance to the Esplanade, providing a framework for the 700-foot reflecting pool and the imposing Hall of State. (Courtesy Andy Hanson.)

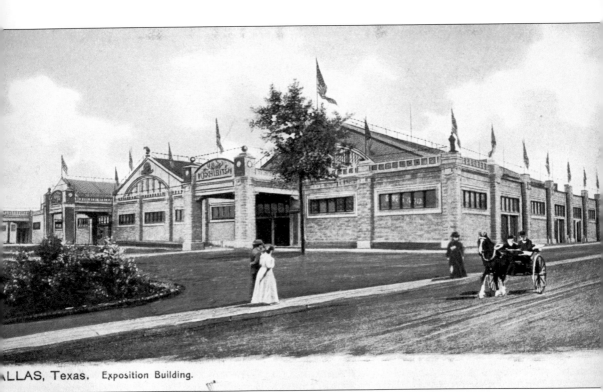

EXPOSITION BUILDING. The State Fair of Texas has been important to the culture and economic viability of Dallas since it began in 1886. In 1904, Fair Park was transferred to the City of Dallas in a move to save the grounds from being purchased by developers. Seventy-five-thousand dollars were set aside for a building that would provide an auditorium and exhibition space. The Romanesque three-gabled building designed by German-born architect Otto H. Lang was erected in 1905 to replace an earlier structure that had been destroyed by fire. The stone-clad fireproof building made of concrete and steel was 125 feet by 150 feet with a concert hall seating capacity of 4,500. In 1936, in preparation for the Texas Centennial Exposition, the stone porticos were removed and the building was extended to twice its original length, adding monumental porticoes that transformed the facade into its present Art Deco form. The original form of the building is still visible from the rear.

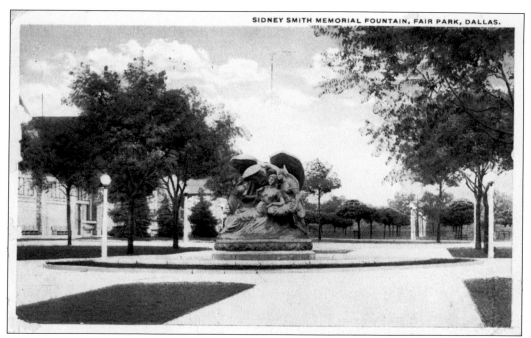

SYDNEY SMITH MEMORIAL FOUNTAIN. Executed by Dallas artist Clyde Giltner Chandler in 1916 to honor Capt. Sydney Smith, secretary of the Texas State Fair Association for 26 years, Gulf Clouds is composed of grey granite and bronze. The figures depict a mother seated, embodying the prairies, with three daughters: the first (to the left) signifies the mountains; the second, representing the Gulf; and the third, the winged Gulf Cloud figure.

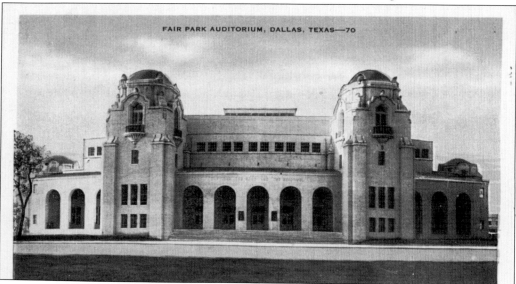

FAIR PARK AUDITORIUM, DALLAS, TEXAS—70

FAIR PARK AUDITORIUM. Architects Lang and Witchell submitted this winning entry in a limited-design competition in 1925. The octagonal towers capture the essence of Spanish Colonial Revival in the building, which seats 3,500 people and cost a total of $500,000. The auditorium was envisioned as a state-of-the-art setting for opera and theatrical venues. Minimal alterations were made to the interior during the 1936 centennial to accommodate the General Motors automobile showroom.

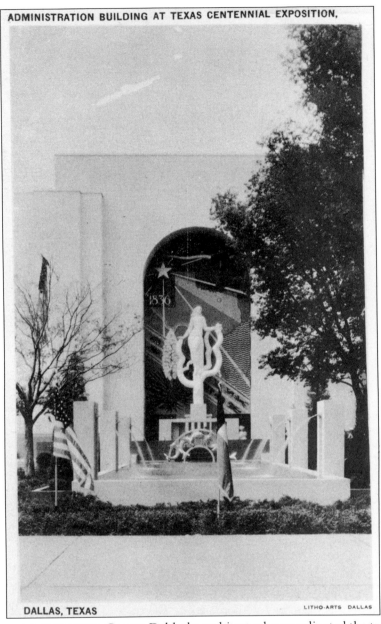

DALLAS, TEXAS

LITHO-ARTS DALLAS

ADMINISTRATION BUILDING. George Dahl, the architect who coordinated the transformation of the state fair grounds for the Texas Centennial, rebuilt this structure—a 1910 coliseum used for horse shows—with an Art Deco facade to serve as the exposition's administration building. Distinctive artwork, both sculpture and murals, was an important part of the celebratory experience at the centennial. Raoul Josset's iconic sculpture, *Spirit of the Centennial,* stands in the central arch in front of a mural by Carlo Ciampaglia. This sculpture, along with Allie Tennant's *Tejas Warrior* located in front of the Hall of State, remains one of the most beloved representations of centennial design. Josset came to the United States in 1926 as part of a group of European sculptors recruited to bring Art Deco to America. He executed three other figural sculptures, representing the United States, Mexico, and France, along the esplanade. The building now houses the Women's Museum: An Institute for the Future.

76

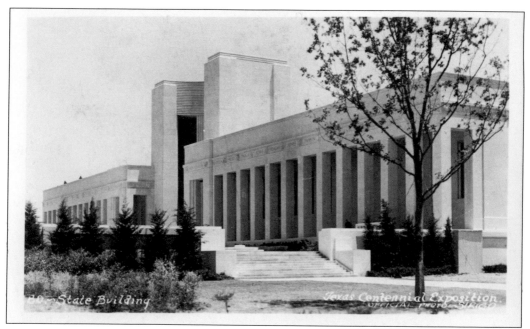

HALL OF STATE. Donald Bartheleme designed the Hall of State, the main Texas Centennial building, in Classical Moderne style, memorializing Texas heroes named within the frieze. Allie Tennant's bronze sculpture, *Tejas Warrior*, graces the entryway of the building. Texas products, including limestone and marble, were used throughout the structure, which features a grand Hall of State and Pompeo Coppini's six bronze sculptures of Texas heroes. The Dallas Historical Society now occupies the building.

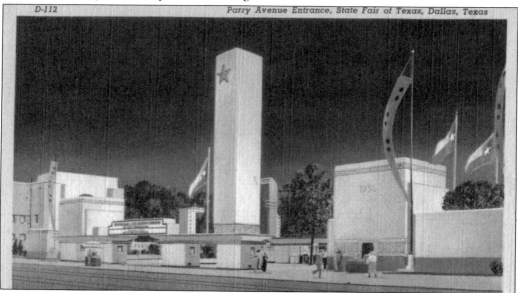

PARRY AVENUE ENTRANCE. A striking contrast against the night sky, the 85-foot-high pylon defines Lang and Witchell's Art Deco–style design of the Parry Avenue Entrance, once a vehicular entry into Fair Park. The pylon is crowned by a gold star representing the Lone Star of Texas. At the base is a frieze of a buffalo hunt and pioneer wagon train designed by Texas artist James Buchanan Winn Jr.

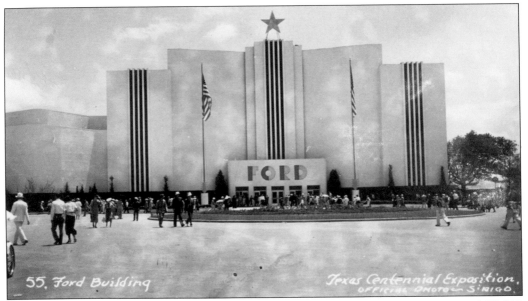

FORD BUILDING. The Art Deco–style Ford Building, demolished in 1938, contained 55,000 square feet and was the largest exhibit building of the centennial. Designed by architect Albert Kahn, it featured a semicircular stepped facade and stepped roofline. On exhibition were Henry Ford's first car, the Model A from 1905, and an early Model T from 1908. During the Greater Texas and Pan-American Exposition, it was repainted and functioned as the Pan-American Building.

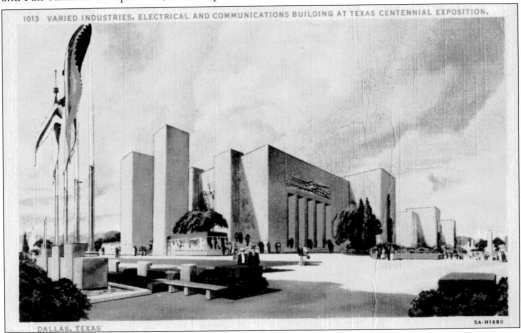

VARIED INDUSTRIES BUILDING. Originally constructed in 1920, this exhibit hall was transformed for the Texas Centennial by architect George Dahl with an Art Deco facade. During the centennial, it housed the Coca-Cola exhibit—a functioning bottling plant producing 100 bottles a minute of Coke. After being destroyed by fire in 1942, it was replaced in 1947 with the Automobile Building, which was reconfigured in 1986 into its present Art Deco style.

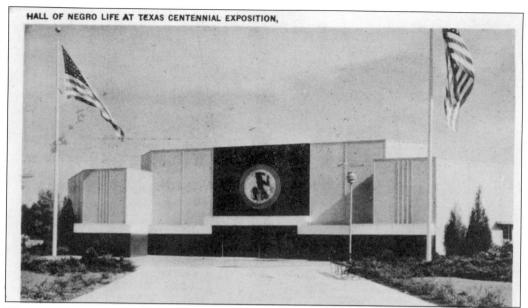

HALL OF NEGRO LIFE. This building housed the first major exhibition celebrating the accomplishments of African Americans at a world's fair and included murals by Harlem Renaissance artist Aaron Douglas. It was dedicated on June 19, 1936, often called "Juneteenth," the anniversary of the day in 1865 when Texas slaves learned of emancipation. It was the first building demolished after the centennial closed. The site is now occupied by the African American Museum.

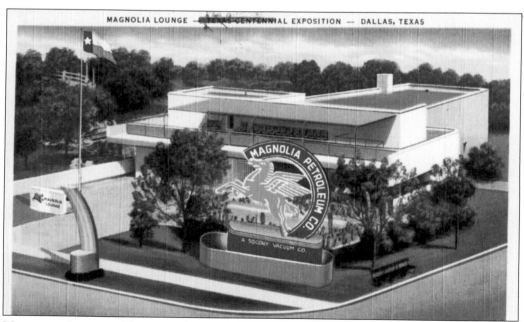

MAGNOLIA LOUNGE — TEXAS CENTENNIAL EXPOSITION — DALLAS, TEXAS

MAGNOLIA LOUNGE. The Magnolia Petroleum Company sponsored this lounge that was designed by William Lescaze, a Swiss-born New York architect. Initially considered too modernistic for the exposition, this building illustrates characteristics of International style with its cantilevered decks and floating planes rather than the prevailing Art Deco or Moderne style. The Magnolia Lounge later housed a theater-in-the-round founded by Texas producer and director Margo Jones.

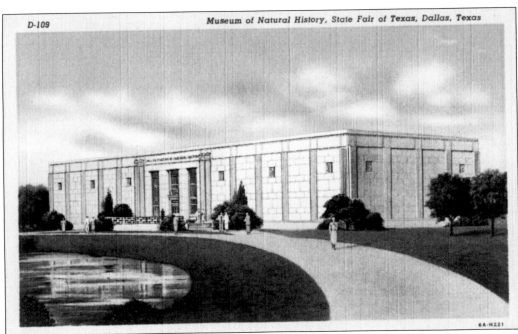

6A-H221

MUSEUM OF NATURAL HISTORY. Designed by architects Mark Lemmon and C. H. Griesenbeck, this restrained neoclassic limestone-clad building exhibits Minimal details such as the fluted pilasters with shell-motif capitals. The museum's intent was to tell the history of Texas from the dinosaur period. As preparations were underway for the state-of-the-art exhibition, Texas Centennial visitors were invited to watch the artisans prepare the naturalistic scenery for the wildlife exhibits.

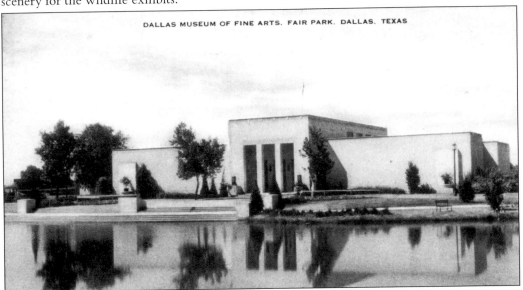

DALLAS MUSEUM OF FINE ARTS. FAIR PARK. DALLAS. TEXAS

DALLAS MUSEUM OF FINE ARTS. The centerpiece of the cultural district, this Neoclassical building has an exterior of cream limestone and shell stone. The design was done by a consortium of architects led by DeWitt and Washburn and assisted by Philadelphia architect Paul Phillippe Cret. The centennial exhibit contained 750 pieces of artwork worth $70 million and encompassed ancient, modern, and Southwestern art, bringing Dallas to the forefront as an art venue.

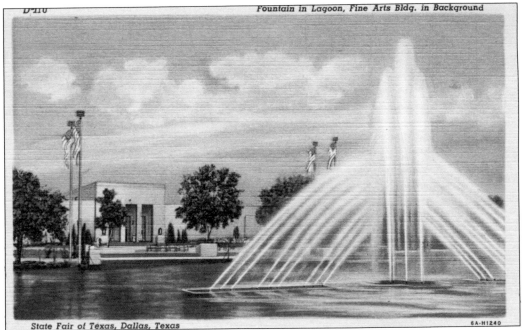

State Fair of Texas, Dallas, Texas

FOUNTAIN IN LAGOON. This scene highlights the dramatic fountain within the lagoon with the Fine Arts Building as a backdrop. George Kessler's plans in 1906 called for formal water features balanced with a pastoral setting based on the prevailing notions of the City Beautiful movement. As the city began preparing for the centennial, features such as this $20,000 fountain became a reality, fulfilling Kessler's grand plan for Fair Park.

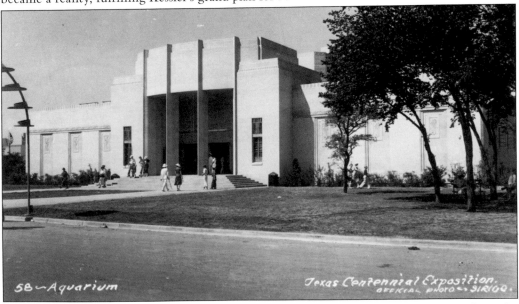

58 Aquarium

Texas Centennial Exposition. OFFICIAL PHOTO 31R/60.

AQUARIUM. A raised pavilion and loggia featuring slender zigzag-shaped columns form the approach to the Dallas Aquarium. Architects Fooshee and Cheek, Hal Thomson, and Flint and Broad provided the aquarium with Moderne elements, a stepped roofline, and intricate brick detailing to relieve the austere quality. The aquarium was touted as the 12th of its kind and featured balanced tanks—a combination of plant life and marine life.

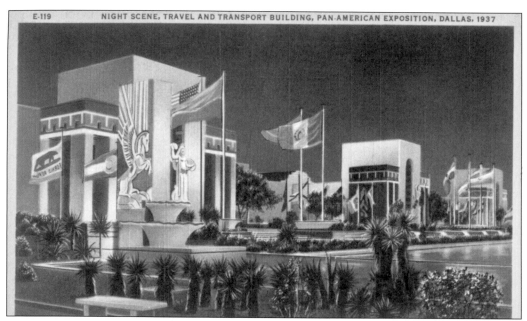

NIGHT SCENE, PAN-AMERICAN EXPOSITION. The 1936 Texas Centennial Exposition was so successful that it was reprised the following year as the Pan-American Exposition, celebrating the cultures of Central and South America. Depicting the Travel and Transportation Building in its nightly splendor, this view of the Esplanade evokes the colorful display. Albert Einstein opened the exposition from Princeton, New Jersey, on June 13, 1937, by pressing a key that illuminated the fairgrounds.

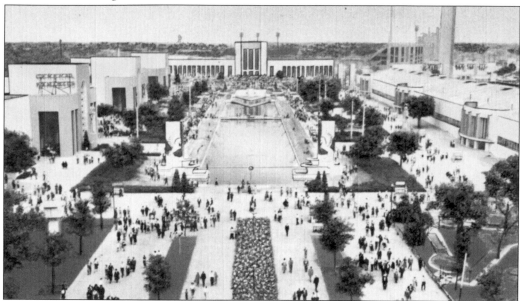

ESPLANADE, C. 1950. This view of the Esplanade facing east from Perry Avenue toward Hall of State provides a history lesson. The original concept of the Art Deco buildings on either side of the reflecting pool is altered by Walter Ahlschlager's modernistic Automobile Building (right), which replaced the Varied Industries Building that was destroyed in a 1942 fire. The 1948 building was remodeled in 1986 to a more appropriate Art Deco form.

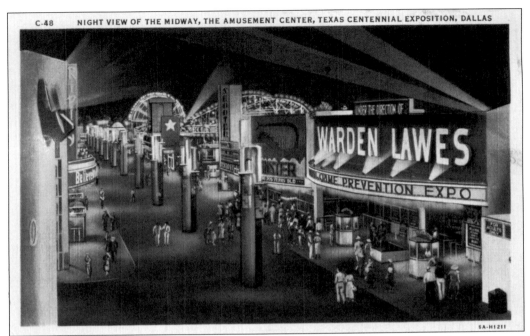

NIGHT VIEW OF THE MIDWAY. The midway structures of the centennial, no longer extant, continued the Art Deco/Art Moderne style of the exposition and were arranged in a linear pattern to create the effect of narrow streets with entertainment venues such as Times Square in New York. The midway during this era featured sensationalized entertainment such as the *Streets of Paris* and *Ripley's Believe or Not*.

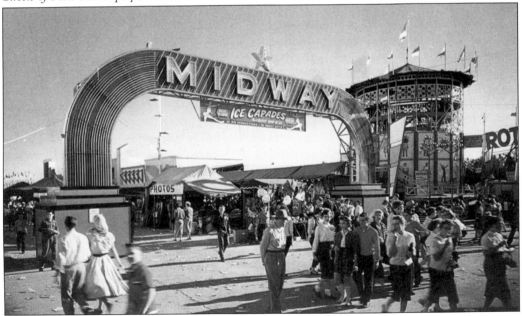

MIDWAY, THE 1950s. The entrance to the Midway in the 1950s was much the same as the present-day Midway. Admission to the fair was only 6¢. This state fair featured the *Ice Capades*, which was introduced into the fair in 1941 on the ice arena. The ubiquitous roller coaster and Ferris wheel were popular attractions, as was Neil Fletcher's corny dog, introduced in 1942.

83

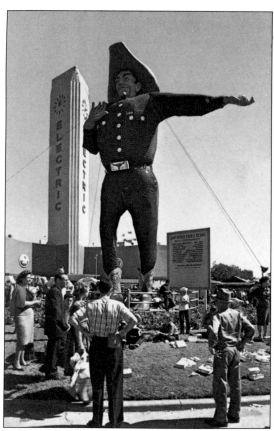

BIG TEX. Introduced to the Texas State Fair in 1952, Big Tex was the brainchild of R. L. Thornton, who saw potential in the pipe and papier-mache Kerens, Texas, Santa Claus. Transformed by Jack Bridge, Big Tex stands 52 feet high and wears sports size 70 boots, a 75-gallon hat, a size 100 shirt, and 284W/185L Lee jeans. In 1954, Jim Lowe became Big Tex's voice for 39 years, greeting fairgoers with "Howdy, Folks."

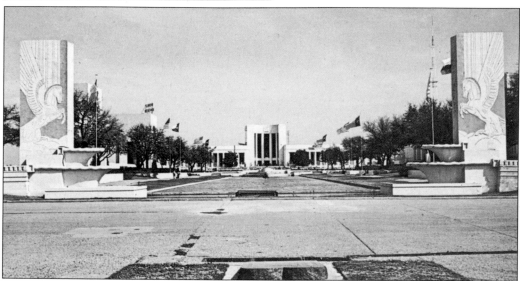

ESPLANADE, C. 1960. As Fair Park's buildings aged, murals were painted over, the gilding on the sculptures wore off, and the Art Deco glory gave way to a light brown, drab appearance. Then the distinction of this unique collection of buildings began to be recognized, the complex was listed as a National Historic Landmark (along with Dealey Plaza and Highland Park Village), and the city began efforts to restore Fair Park.

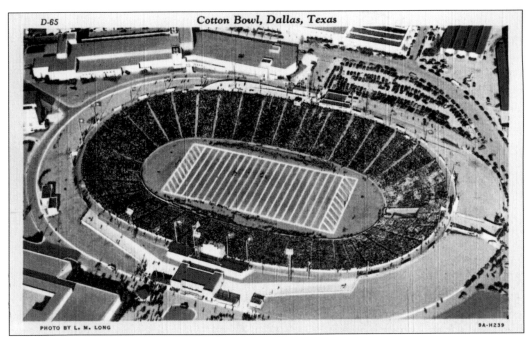

Cotton Bowl, Dallas, Texas

PHOTO BY L. M. LONG 9A-H239

COTTON BOWL. Fair Park Stadium was designed by architect Mark Lemmon in 1930 as a single-tiered concrete bowl of cut-and-fill construction 24 feet below grade. Renamed the Cotton Bowl in 1936, and home to the annual Cotton Bowl Classic beginning in 1939, the stadium was expanded several times. With a seating capacity of 46,000, it was the largest stadium in the South.

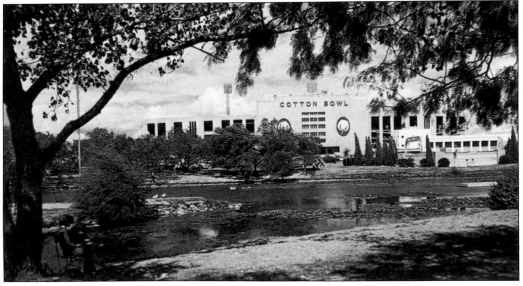

COTTON BOWL (ENTRANCE). The Cotton Bowl was home to the Dallas Cowboys from 1960, the year of the team's formation, until 1971. It has been the setting for numerous special occasions such as the visit of Pres. Franklin Delano Roosevelt during the centennial. Gen. Douglas MacArthur, Norman Vincent Peale, and Billy Graham made appearances here. USO shows were performed at the Cotton Bowl, and heartthrobs Frank Sinatra and Elvis Presley also gave concerts here.

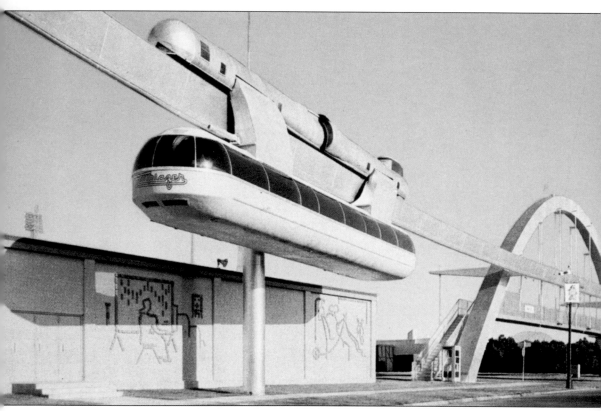

SKYWAY MONORAIL. The Skyway Monorail was introduced at Fair Park in 1956, three years before the Disney Corporation introduced the Alweg Monorail in Disneyland. It was 54 feet long, seated 55 passengers, and was powered by a 310-horsepower Packard engine with the ability to attain a speed of up to 250 miles an hour. The 4,000-foot route ran from the corner of the Automobile Building near the State Fair Auditorium along the north-south border of the fairgrounds, then parallel to Pennsylvania Avenue. The monorail was suspended 21 feet above the ground. The main loading platform was suspended from a parabolic arch opposite the main entrance to the Cotton Bowl. At a cost of 25¢ per ride, the monorail was the first commercial operating line in the United States. The monorail was dismantled in 1964 and purchased by Goodell Monorail Museum in Houston. It was replaced at Fair Park by the Swiss Sky Ride.

Six

HOUSES OF WORSHIP, CEMETERIES, AND SCHOOLS

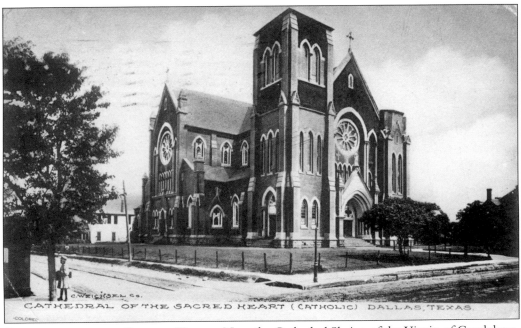

CATHEDRAL OF THE SACRED HEART. Now the Cathedral Shrine of the Virgin of Guadalupe, this 1902 High Victorian Gothic landmark is Dallas's only extant work by master Galveston architect Nicholas Clayton. As designed, the Roman Catholic church at the corner of Ross and Pearl Streets was to have two towers, but they were not built because of cost considerations. In 2002, the cathedral began to raise funds as part of its centennial celebration, and in 2004 the two towers were built according to Clayton's original plans.

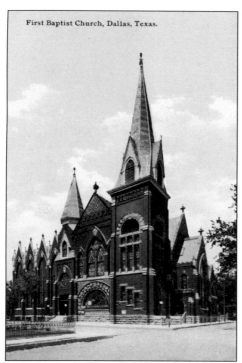

First Baptist Church, Dallas, Texas.

FIRST BAPTIST CHURCH. Erected in 1890 on North Ervay Street, First Baptist Church is one of downtown's oldest surviving Victorian-era structures. It was designed by Dallas architect Albert Ullrich, who later relocated to New York. The congregation, formed in 1868, first occupied a frame structure at Akard and Patterson Streets and moved to the present location when the 1890 sanctuary opened. Well-known pastors George Truett and Dr. W. A. Criswell led the church from 1897 to 1995. (Courtesy Errol Miller.)

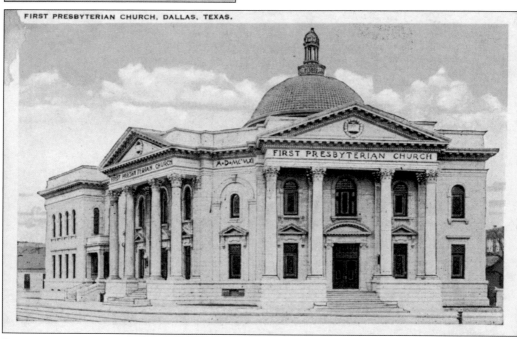

FIRST PRESBYTERIAN CHURCH, DALLAS, TEXAS.

FIRST PRESBYTERIAN CHURCH. The First Presbyterian Church, located at the corner of Harwood and Wood Streets, is the fourth building occupied by the First Presbyterian Church congregation, which was organized in 1868. Built in 1912–1913, the Neoclassical Revival structure represents the work of noted Dallas architect C. D. Hill. The church's design strongly complements that of one of Hill's other buildings, Dallas's Municipal Building, which is also located on Harwood Street.

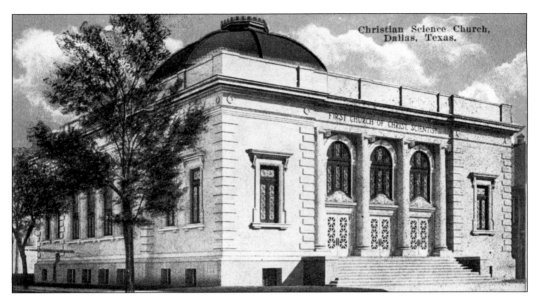

FIRST CHURCH OF CHRIST SCIENTIST. Employees of Dallas architectural firm Hubbell and Greene designed this Neoclassical-style edifice, inspired by the mother Christian Science church in Boston. The building boasted a custom-designed organ by Hook and Hasting of Boston when it opened in 1912. The organ, which remains intact, was the first in Dallas to feature electrical components. In 1999, the former church was renovated into the Weisfeld Center, an 800-seat theater.

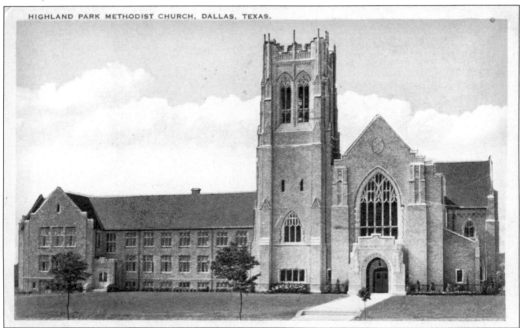

HIGHLAND PARK METHODIST CHURCH. Highland Park Methodist Church, located on the edge of Southern Methodist University's (SMU) campus, represents one of the Methodist denomination's largest congregations. The church body was first organized in 1916, and the current sanctuary was built in 1926 on land donated by SMU. Architect Mark Lemmon's design was inspired by pastor Dr. Umphrey Lee's dream of a campus cathedral rich in Gothic detail.

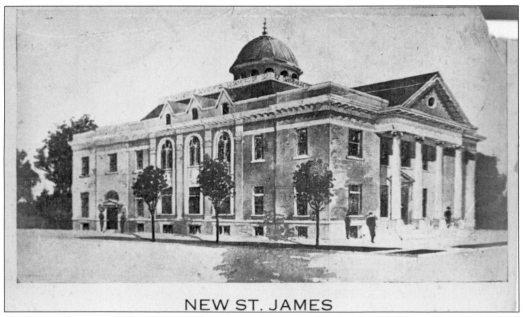

NEW ST. JAMES

ST. JAMES AFRICAN METHODIST EPISCOPAL CHURCH. Under the ministry of Dr. Charles W. Abington, St. James Church was dedicated in 1921 at the corner of Florence and Good Latimer Streets. It was designed by William Sidney Pittman, the state's leading African American architect who designed several other AME churches, including the Allen Chapel AME Church in Fort Worth and Joshua Chapel AME Church in Waxahachie. The building now houses offices.

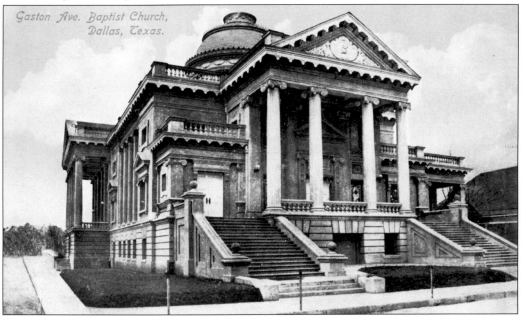

GASTON AVENUE BAPTIST CHURCH. Designed in 1904 by Charles W. Bulger, the Gaston Avenue Baptist Church, now Criswell College Library, is an impressive Grecian edifice of gray pressed brick and white stone. Its appearance is based on the First Baptist Church of Galveston that is also Bulger's design. Bulger and his son designed more than 100 churches in the Southwest, including Dallas's McKinney Avenue Baptist Church, now demolished.

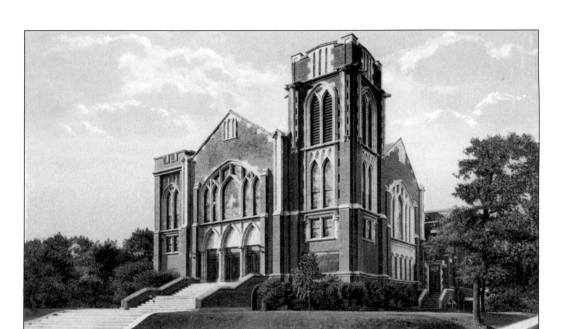

OAK LAWN METHODIST CHURCH. Dallas architect Charles D. Hill designed this late Gothic Revival–style church at 3014 Oak Lawn Avenue. Built in stages between 1911 and 1915 as funding became available, this brown brick two-story church features light terra-cotta detailing. The building has undergone two additions in the back, one completed in 1928 and the other in 1950. (Courtesy Old Red Museum of Dallas County History and Culture.)

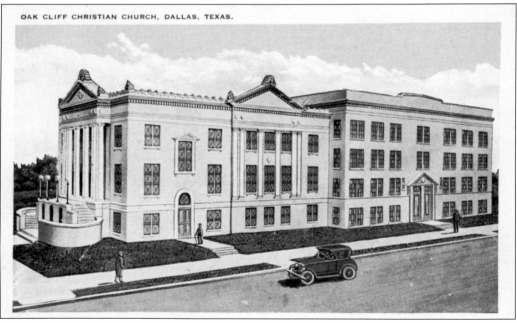

OAK CLIFF CHRISTIAN CHURCH. In 1915–1916, the Oak Cliff Christian Church replaced an earlier frame building with this handsome new structure designed by Van Slyke and Woodruff of Fort Worth. The sanctuary at East Tenth and Crawford Streets was built to hold 1,200 people. A Sunday school wing was added in 1926. The building remained the home of this neighborhood congregation for nearly 50 years; it now serves Revival Tabernacle.

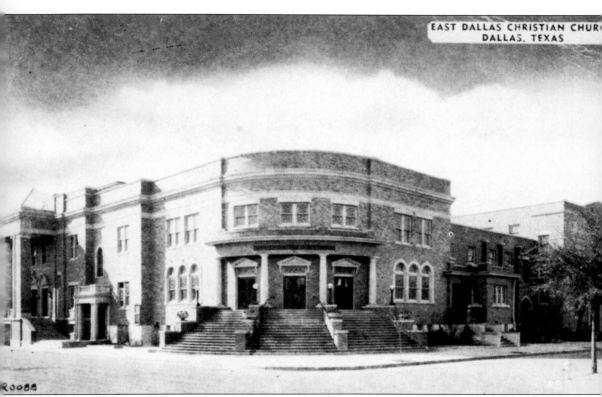

EAST DALLAS CHRISTIAN CHUR(
DALLAS, TEXAS

EAST DALLAS CHRISTIAN CHURCH. This neighborhood church grew rapidly after it was established in 1903. A new sanctuary was dedicated in 1912 at the corner of Peak and Junius Streets. In 1923–1924, the congregation hired architect C. D. Hill to design a new sanctuary, which retained the corner curving steps of the 1912 church, and convert the old one for use as a Sunday school building. (Courtesy DPL.)

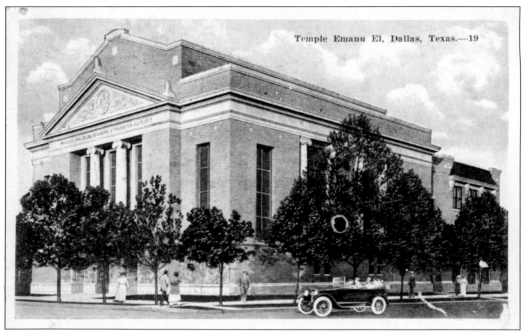

TEMPLE EMANU–EL. In 1872, Dallas's oldest Jewish congregation, Temple Emanu-El ("God with us"), was founded with the formation of the Hebrew Benevolent Association. The association, one of the first in the state, pledged to nurse the sick, rescue the stranger, and bury the dead. In 1876, the members built their first temple, located on Commerce Street. In 1889, they moved to their second location on South Ervay Street, followed by a third completed in 1916 on Harwood Street and South Boulevard (above). Today Temple Emanu-El occupies an 18-acre campus located at Northwest Highway and Hillcrest Avenue in North Dallas. The domed brick–and–glass synagogue (below), designed by Howard R. Meyer and Max M. Sandfield in 1957, is home to one of the largest Jewish congregations in the South.

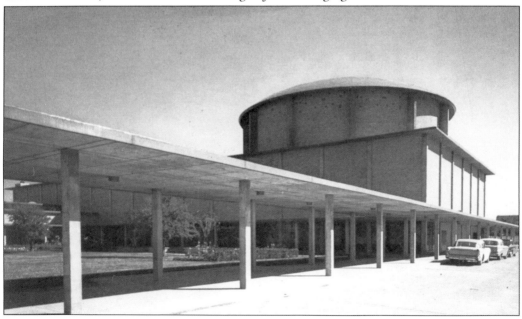

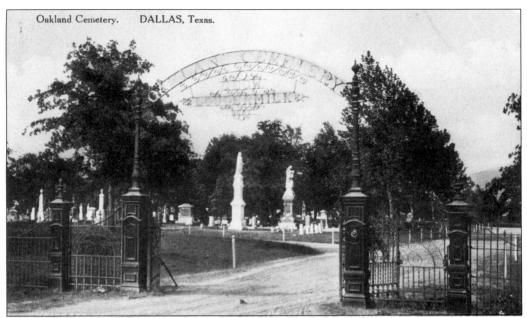

Oakland Cemetery. DALLAS, Texas.

OAKLAND CEMETERY. Local entrepreneur George Loudermilk and other citizens purchased 51 acres in southern Dallas to establish Oakland Cemetery after space became limited at the city's four downtown cemeteries. Dedicated in 1892, it is the final resting place for many prominent citizens, including Richard Gano, John McCoy, and Henry Exall. It features many ornate Victorian-era tombstones and monuments. (Courtesy Old Red Museum of Dallas County History and Culture.)

FAMOUS BOTANICAL ROCK GARDEN LAUREL LAND MEMORIAL PARK, DALLAS

LAUREL LAND MEMORIAL PARK. Established in 1922 as the New Oak Cliff Cemetery at 6000 South R. L. Thornton Freeway and renamed Laurel Land by 1930, this cemetery reflects a trend in the late 1930s to make Texas cemeteries more park-like. Paving the way, Laurel Land installed a botanical rock garden complete with a waterfall and chimes. Still in operation, the cemetery remains a peaceful site for thoughtful reflection.

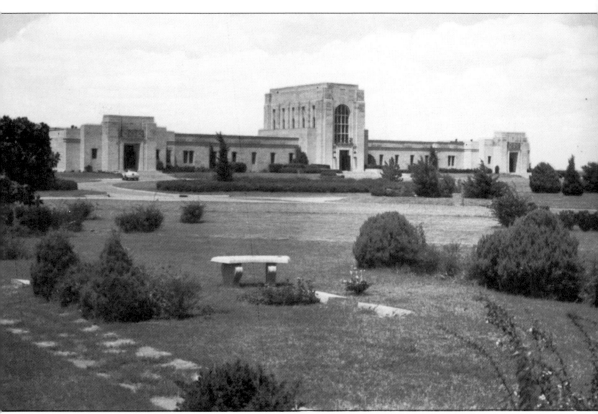

HILLCREST MAUSOLEUM. A first of its kind in Dallas, Hillcrest Memorial Park's Mausoleum on Northwest Highway was erected in 1936–1937. Its limestone edifice was designed in the Beaux Arts style with Art Deco detailing by noted architect Anton Korn. The memorial theme of the building was carried through in the interior's cathedral ceilings, stained-glass windows, and marble finishes. A ventilating system ensured constant fresh air in mausoleum crypts.

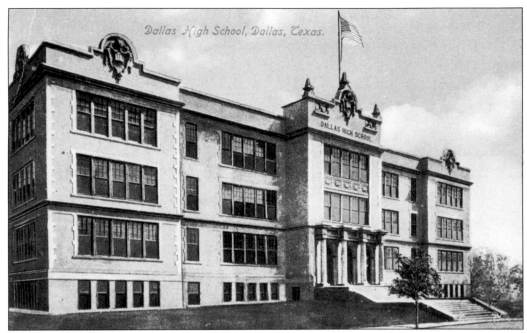

DALLAS HIGH SCHOOL. Dallas High School, completed in 1908, was located on the site of the first public high school in Dallas, established in 1884. In 1928, it became Dal-Tech High School, the first in the city to offer both vocational and academic classes. When it closed in 1995, the school was the oldest school building still in use and had served students for 87 years. The building awaits a new use.

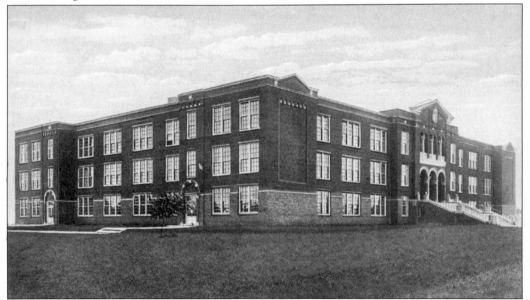

SUNSET HIGH SCHOOL. In 1925, thirty-nine teachers and 1,400 students became the first occupants of Sunset High School. The school's construction on Jefferson Avenue reflected the rapid development of southwest Oak Cliff during the 1920s that coincided with the extension of street railway lines. Sunset had the same general plan as Forest Avenue, Oak Cliff, and North Dallas High Schools, though its capacity was the largest in the city.

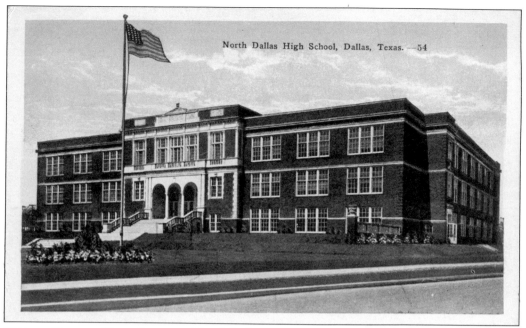

North Dallas High School, Dallas, Texas. —54

NORTH DALLAS HIGH SCHOOL. North Dallas High School, on Cole Avenue, was located on the city's northern edge when it was established in 1922. It remained the northernmost high school until the early 1950s when Hillcrest and Thomas Jefferson High Schools were built. The tapestry brick building with limestone trim was designed by architect William B. Ittner. Today it is Dallas's fourth-oldest high school.

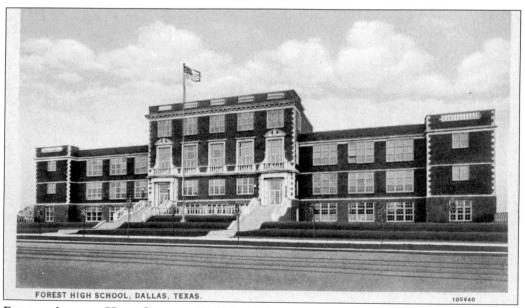

FOREST HIGH SCHOOL, DALLAS, TEXAS. 105640

FOREST AVENUE HIGH SCHOOL. Built in 1916 on Forest Avenue (now Martin Luther King Jr. Boulevard), Forest Avenue High School was designed in the Italianate Renaissance style by St. Louis architect William B. Ittner, who also designed Oak Cliff and later North Dallas High Schools. Forest Avenue initially served white students. In 1956, it was designated as a high school for African Americans, and the name changed to James Madison. Integration came in 1976.

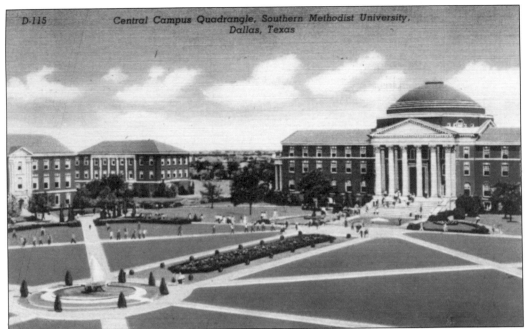

DALLAS HALL. SMU's first president, Robert Hyer, selected for the campus a Georgian architectural style, which was inspired by Thomas Jefferson's plan for the University of Virginia. Classes began in 1915 in Dallas Hall, the domed structure, which initially housed all classrooms, offices, a chapel, library, barbershop, and bank. Gradually more buildings were erected, all in the same harmonious style, beginning with those around the main academic quadrangle. (Courtesy Andy Hanson.)

BISHOP COLLEGE. This historically black college, founded in Marshall, Texas, by the Baptist Mission Society, moved to Dallas in 1961. A building program at the site on Simpson Stuart Road was supported by both whites and African Americans. The Carr P. Collins Chapel, designed by Chicago architect Robert Kleinschmidt, was dedicated in 1967. Bishop closed in 1988, and in 1990 another established African American institution, Paul Quinn College, relocated to the campus.

Seven

TRANSPORTATION

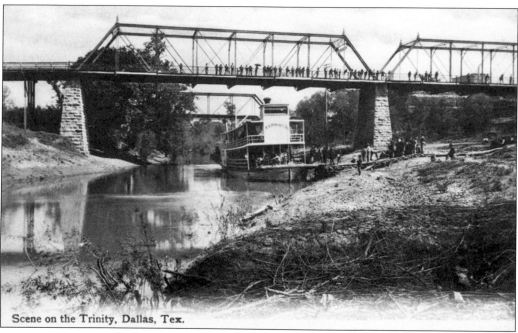

Scene on the Trinity, Dallas, Tex.

TRINITY RIVER. John Neely Bryan, who established Dallas, anticipated that the Trinity River would become a trade and transportation route. However, early efforts to navigate the Trinity proved slow and expensive, and only a few boats made the journey. When railroads reached Dallas in 1872 and 1873, interest in the Trinity as a shipping route dwindled. Dallas's future as a transportation center would depend on rail, auto, and airplane—not water. (Courtesy OPL.)

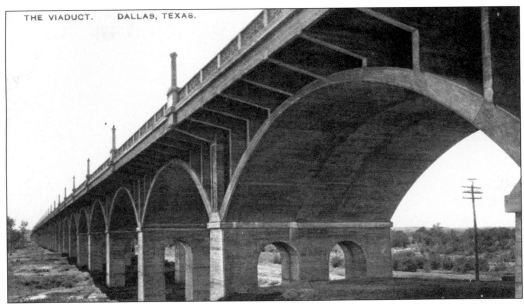

HOUSTON STREET VIADUCT. Following the disastrous flood of 1908 that destroyed the bridge connecting downtown Dallas to the suburb of Oak Cliff, Dallas County commissioned one of the longest viaducts ever constructed. Ira G. Hedrick designed the 6,562-foot-long by 56-foot-wide reinforced concrete span. The viaduct contains 51 arches measuring 79 feet and 6 inches high and rests on pile footings. A 100-foot-long steel girder spans the river, allowing for the vertical clearance necessary for the barge traffic that Dallas expected but which never came. This girder was also fitted with vertical bearing surfaces, or "shoes," that would allow ocean-going vessels into the city. The construction cost was $570,000. The viaduct remains relatively unchanged, with a handrail added in the 1930s and a staircase leading to the parking lot of Reunion Arena added in the 1970s. (Above, courtesy Errol Miller.)

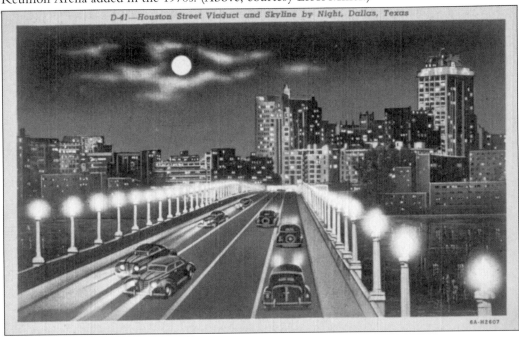

D-41—Houston Street Viaduct and Skyline by Night, Dallas, Texas

SANTA FE BUILDINGS - UNIT I HEADQUARTERS EIGHTH SERVICE COMMAND

UNIT 1 UNIT 2 UNIT 3 UNIT 4

COMMERCE TO YOUNG STREETS
DALLAS, TEXAS

SANTA FE BUILDINGS. The Santa Fe Freight Terminal and Warehouses, located between Commerce and Young Streets, consisted of four separate buildings once connected by an underground tunnel system. The immense complex centralized the Gulf, Colorado, and Santa Fe Railroad's transfer and warehousing operations in Dallas. It also importantly removed tracks from the congested street surface. Construction began in 1924, with the railroad headquarters in the 20-story Building No. 1, followed by merchandise warehouses in Building Nos. 2, 3, and 4. Building No. 1 was later purchased by the federal government with a U.S. Army recruiting office operating there during World War II. It still houses government offices. Building No. 2 included the University Club, a two-story rooftop club. The building is now condominiums. Building No. 3 was demolished in 1988, and Building No. 4 is now a luxury boutique hotel.

D-52 Santa Fe Building, Dallas, Texas

Katy Office Building, Dallas.

MKT BUILDING. For more than 50 years, this seven-story, terra-cotta and masonry building at 701 Commerce Street provided office space for the Missouri, Kansas, and Texas (MKT of "Katy") Railway Company headquarters in Dallas. This distinctive building, completed in 1912, was owned by Col. John N. Simpson and designed by H. A. Overbeck. Although the MKT occupied most of the building, space was allocated to other businesses. Considered modern for its time, the reinforced concrete building was fireproof and had a power plant in the basement. The use of dark brick, gilded ornamentation, and detailing at the projecting cornice, however, gave the building a stately appearance. The MKT Building was renovated in 1978 by Thomas E. Woodward. By 1989, the MKT Railway Company had been absorbed by other railway companies, and thus no longer existed. The MKT Building still serves as a reminder of the important role of railroads to the city's growth.

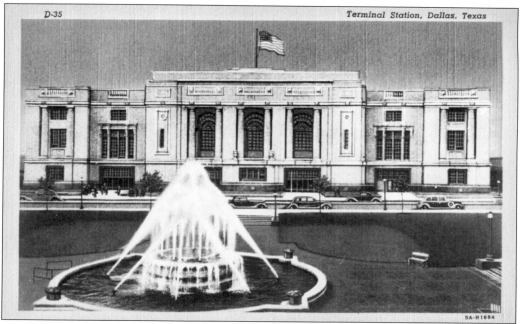

5A-H1684

UNION STATION. City planner George Kessler recommended constructing Union Station in 1911 to get the railroad tracks off busy downtown Dallas streets. Completed in 1916, this Beaux Arts terminal, designed by Chicago architect Jarvis Hunt, allowed five earlier stations used by nine railroads to close. Union Station immediately became the city's gateway as thousands passed through each day. Passengers enjoyed an impressive second-level waiting room with a 48-foot vaulted ceiling. As passenger rail service slowed during the 1950s, use of the station declined, and it was even used as a temporary central library location because it was the only building in town that could hold the weight of the book stacks. Union Station was restored in 1974, and again in 2008, and currently serves DART, Trinity Railway Express, and Amtrak passengers. (Below, courtesy private collection.)

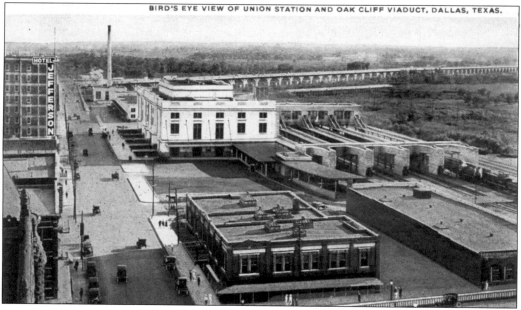

BIRD'S EYE VIEW OF UNION STATION AND OAK CLIFF VIADUCT, DALLAS, TEXAS.

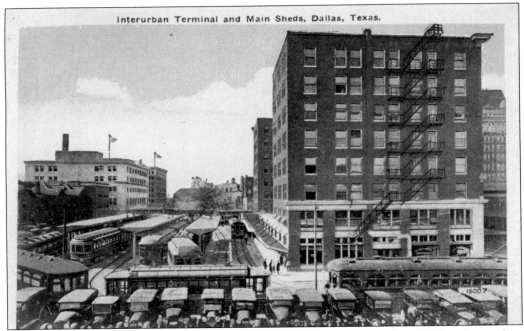

Interurban Terminal and Main Sheds, Dallas, Texas.

INTERURBAN BUILDING. The Interurban Building was constructed in 1916 as interurban railways in Dallas were taking hold, joining the then outlying suburbs and communities with the city's center. The nine-story building could accommodate 35 interurban trains at once, with lines reaching as far as Denison, Corsicana, Fort Worth, and Cleburne. Eventually interurban railways were replaced by bus systems, and the building became the office and station for the Trailways Bus Company in the early 1950s. Shortly thereafter, the building was remodeled, and much of the original ornament was removed from the facade. By 1987, it was vacant. The building was purchased and converted into loft apartments in 2005 with a grocery store and café on the first floor. The store was the first to be introduced in downtown to serve the burgeoning population of loft, apartment, and condominium dwellers.

CENTRAL EXPRESSWAY. Although it appears a marvel of modern engineering in this early 1950s postcard, Central Expressway, so named because it followed the old tracks of the Houston and Texas Central Railroad, was soon plagued by narrow lanes, short entrance ramps, and inadequate capacity for postwar traffic. Rebuilt and expanded between 1992 and 1999, Dallas's first freeway now has eight well-designed lanes with cantilevered service roads and handsome architectural detailing.

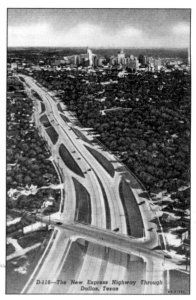

D-116—The New Express Highway Through Dallas, Texas

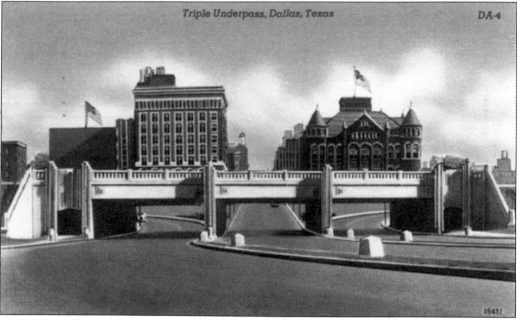

Triple Underpass, Dallas, Texas DA-4

TRIPLE UNDERPASS. The Triple Underpass was a Works Progress Administration Depression-era project that started in November 1934 to create a gateway into downtown Dallas and relieve congestion from traffic using the road to Fort Worth, which was the most heavily traveled highway in Texas at that time. It was built on historic ground located on the site of Dallas founder John Neely Bryan's first cabin, which he erected on the eastern bank of the Trinity River. The cost of the project was just over $1 million. The underpass was designed to handle some 50,000 cars daily, with eastbound and westbound cars passing under a bridge handling passenger and freight traffic from seven railroad lines. A plaza named for George Bannerman Dealey, publisher of the *Dallas Morning News* and the acknowledged "father of city planning" in Dallas, was created in the open space east of the underpass created by the flaring curves of Elm, Commerce, and Main Streets as they approached the underpass from downtown Dallas. (Courtesy Andy Hanson.)

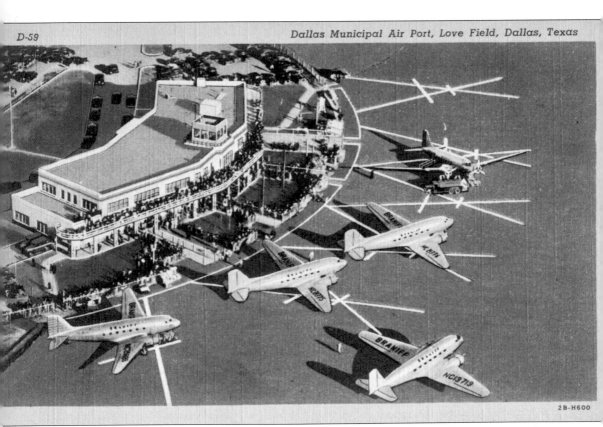

LOVE FIELD. Love Field began as a World War I army airfield covering 1 square mile. In 1927, the city purchased the airfield and added 90 acres, more runways, and lighting. Passenger routes were established to San Antonio and Houston, and Love Field became an airmail stop. By 1940, it served 48 mail and passenger planes daily. Like other airports in the country, it once again became an army airfield during World War II and was the headquarters of the U.S. Air Transport Command. The U.S. Army Air Corps expanded the airport, and when it once again returned to civilian duty, it was one of the largest in the Southwest. Love Field now covers over 1,300 acres and is the headquarters of Southwest Airlines.

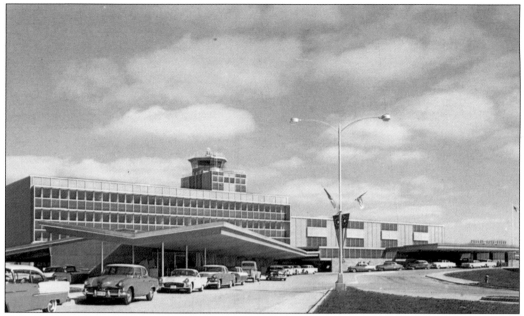

LOVE FIELD, 1960s. With its 1957 terminal designed by Dallas architect Jack Corgan, Love Field became the largest airport in the Southwest, serving eight major carriers. However, Love Field's era as a premier airport was challenged. In 1968, the cities of Dallas and Fort Worth agreed to build a regional terminal, now known as Dallas–Fort Worth International Airport (DFW), midway between the two cities. The major carriers would move to DFW, leaving a new carrier, Southwest Airlines, as the only airline serving Love Field. Enplanements peaked in 1973 with over six million occurring that year. The next year, DFW opened and Love Field's enplanements fell to 467,212. The constant presence of Southwest Airlines has reestablished Love Field as a significant regional airport.

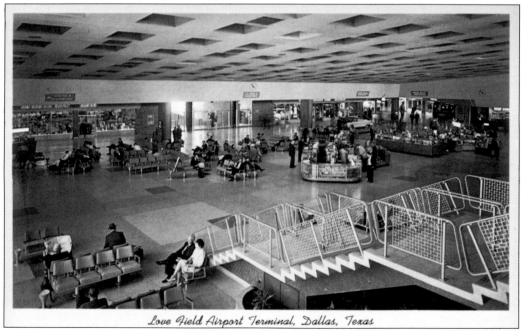

Love Field Airport Terminal, Dallas, Texas

Greetings From "Big D" --
Dallas, Texas

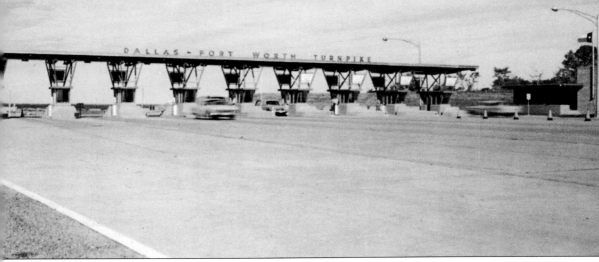

DALLAS-FORT WORTH TURNPIKE. The Dallas fare plaza marked the entry for the Dallas-Fort Worth Turnpike, which cut the travel time between the two cities by half an hour. Construction started on October 5, 1955, and the first cars went through the tollgates on August 27, 1957. In just 23 months, some 2,000 workers used 1.5 million square yards of concrete to create the double three-lane roads that had only three exits between the two cities. At the midway point, two Conoco service stations and two Glass House Restaurants were built to provide service to drivers going in both directions. The fare for the 29.8-mile superhighway was 50¢. Texas Turnpike Authority officials promised tolls would end when the final bond payments were made on the $58.5 million bond issue. Toll collection ended at 6:00 a.m. on December 31, 1977, and the old turnpike has since served as a freeway.

Eight

GONE BUT NOT FORGOTTEN

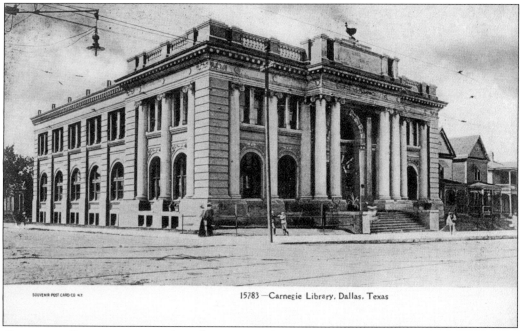

SOUVENIR POST CARD CO N.Y.

15783 —Carnegie Library, Dallas, Texas

CARNEGIE LIBRARY. Located at the corner of Main and Harwood Streets, the Carnegie Library—Dallas's first free public library—opened in 1901. Fort Worth architects Sanguinet and Staats designed a classical building, topped by a "lamp of knowledge," offering a hint of the volumes available inside. Woefully overcrowded by the mid-1950s, this building was demolished and replaced on the same site by George Dahl's modernist structure.

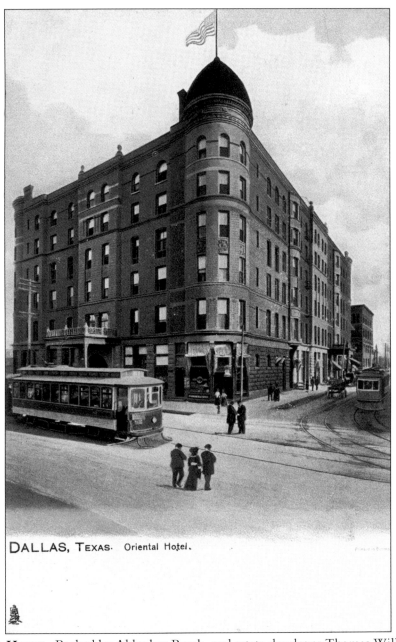

DALLAS, TEXAS. Oriental Hotel.

ORIENTAL HOTEL. Backed by Aldophus Busch, real estate developer Thomas William Field's $500,000 project was billed as the "most elegant hotel west of the Mississippi" when it opened in 1893. The original plans for the six-story Oriental Hotel with a modified onion-domed turret called for turrets on three corners, but it was modified to one turret as can be seen from this view. Although the detail of the exterior was minimal, great attention was paid to the interior finishes and creature comforts. The wainscoted Italian marble entrance opened to a "rotunda radiant with the hues of cathedral glass." The hotel featured a Turkish bath and advertised full electric rooms. In 1905, Pres. Theodore Roosevelt was accommodated in the Presidential Suite after a parade down Elm and Akard Streets. Known as "Field's Folly" because of the exorbitant cost, the Oriental was demolished in 1925 and replaced by the Baker Hotel.

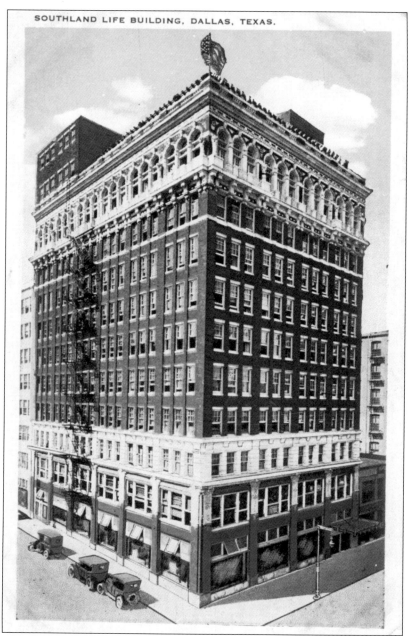

SOUTHLAND LIFE BUILDING, DALLAS, TEXAS.

SOUTHLAND LIFE INSURANCE. Southland Life Building is unique in that Lang and Witchell, prolific Dallas architects who were well versed in all architectural styles, designed this as a two-story building in 1910 with the capability of constructing additional stories. Originally the Chamber of Commerce and Manufacturers' Building, it took the Southland name when the insurance company acquired the building. In 1918, eight stories were added, making it one of Dallas's earliest skyscrapers. Built at a cost of $650,000 and measuring 75 feet by 100 feet, Southland Life Insurance Building had amenities such as mahogany woodwork, three passenger elevators, and hot and cold running water in each office, as well as a rooftop garden. During this era, Dallas was the insurance center for Texas and was one of the largest in the Southwest. The Classical Revival red brick building with intricate white stonework was demolished in 1980.

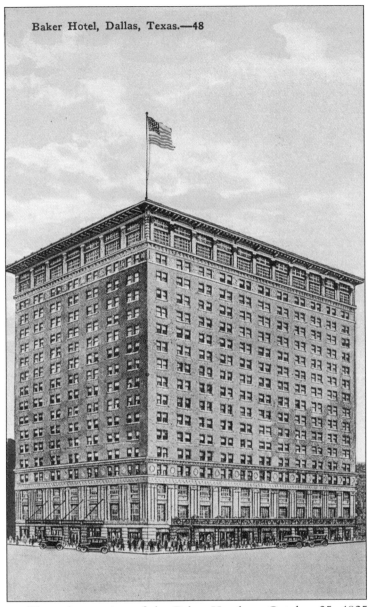

Baker Hotel, Dallas, Texas.—48

BAKER HOTEL. The gala opening of the Baker Hotel on October 25, 1925, was marked by the throwing away of the house keys, symbolizing that the building would remain open day and night. This grand hotel was built on the site of the Oriental Hotel at a cost of $5.5 million. It was constructed by St. Louis architect Preston J. Bradshaw, who had designed the Brown Hotel in Louisville and the Coronado and Chase Hotels in St. Louis. It stood 18 stories high and contained 700 rooms. The two-story lobby was finished in Tavernelle-Cliar marble wainscoting with pink Tennessee marble floors. The interiors were described as being in the Adams style with low relief plastered ceilings. The Mural Room hosted cabaret singer Hildegarde, who provided entertainment for the dinner guests. The Baker was the site of many prominent civic and social events in Dallas, such as the meetings of the Petroleum Club and Press Club and the annual Idlewilde Ball for Dallas debutantes held in the Crystal Ballroom. The Baker was demolished in 1980.

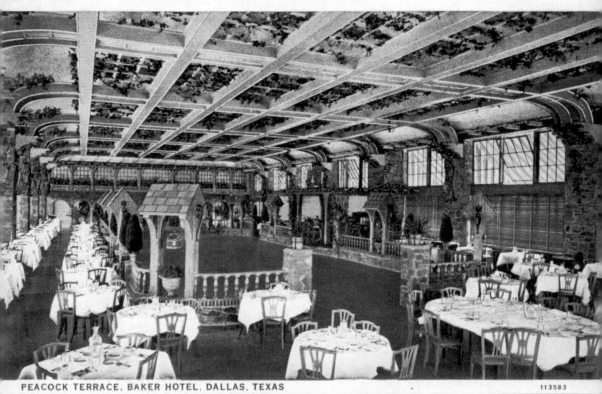

PEACOCK TERRACE, BAKER HOTEL, DALLAS, TEXAS 113583

PEACOCK TERRACE. In June 1926, WFAA-Radio broadcasted the opening of the Peacock Terrace, which was designed to have the effect of an old English inn. A wall of fieldstone and wishing wells encircled the dance floor with the roof of each well shed covering a cage of birds. An indirect lighting system within the latticework of the coffered ceiling created an ethereal effect. During the Big Band era, the rooftop Peacock Terrace at the Baker Hotel hosted WFAA-Radio broadcasts of "Big Bands" such as Kay Keyser, Tommy Dorsey, and Ted Weems with Perry Como, as well as Herbie Kay with Dorothy Lamour. Cab Callaway and Duke Ellington with the Cotton Club Orchestra also made appearances in the Peacock Terrace, which was so named as an enormous peacock with a spread fan surmounted the rooftop.

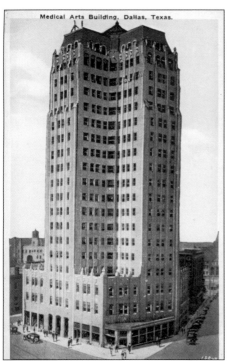

Medical Arts Building, Dallas, Texas.

MEDICAL ARTS BUILDING. Architects Barglebaugh and Wilson's Maltese cross-design Medical Arts Building at Pacific Avenue and North St. Paul Street created a distinctive presence in the 1920s. The 21-story building was the tallest reinforced concrete structure in Texas. Built of cream-colored brick with terra-cotta finials and a mansard roof, it was razed in 1979 and replaced with the eight-story Republic Tower III.

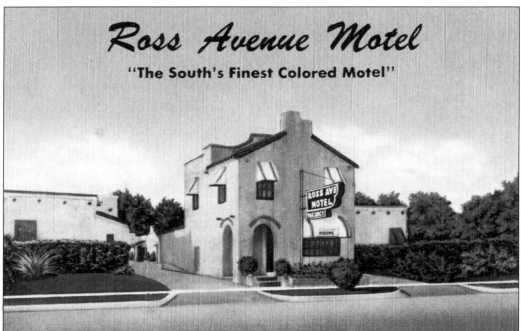

Ross Avenue Motel

"The South's Finest Colored Motel"

ROSS AVENUE MOTEL. Under segregation, traveling African Americans had difficulty finding overnight accommodations. Celebrities often stayed in private homes because the few hotels designated for African Americans could not meet their needs. The Ross Avenue Motel provided an option for motoring tourists by offering adjacent parking and easy access to the rooms. It lost patronage in the 1960s as motorists favored interstate highways and African Americans gained more choices about where they could stay.

DALLAS COTTON EXCHANGE. Dallas's preeminence in the cotton trade was exemplified by the 1925 erection of this 17-story, cream-colored commercial building with terra-cotta ornamentation designed by Dallas architects Lang and Witchell. Built at a cost of $1.5 million and containing 220,000 square feet, the building provided offices for local and international cotton brokers. One-sixth of the world's cotton supply was being produced within 150 miles of Dallas during the early 20th century, and the Dallas Cotton Exchange was the world's largest inland cotton market. In the 1960s, precast concrete panels were applied to the building as a modernization typical of the era. It fell into disrepair in the 1990s, and proposals for redevelopment as residential housing did not materialize. The Dallas Cotton Exchange was imploded on June 25, 1994. The stone lions, a signature architectural detail of the building, now grace the Stoneleigh Hotel's Maple Avenue entrance.

DR PEPPER HEADQUARTERS. The Dr Pepper Headquarters on Mockingbird Lane was the focus of a protracted battle of preservationists and developers that included a federal court case before its destruction in 1997. Designed by Thomas, Jameson and Merrill Architects in 1946, the Art Deco building, with its emblematic "10-2-and 4" clock tower and glass-block exterior, was replaced with the Phoenix Art Deco–style apartments.

BIG TOWN MALL. Big Town Mall was the first enclosed, air-conditioned shopping mall in the Southwest. Located in Mesquite at Loop 12 and Highway 80, it was constructed in 1959 and housed J. C. Penney, Sanger-Harris, and Montgomery Ward. In the aftermath of Hurricane Katrina, Big Town Mall became a stopover for evacuees before they were transferred to Reunion Arena and Dallas Convention Center. The mall was demolished in 2006.

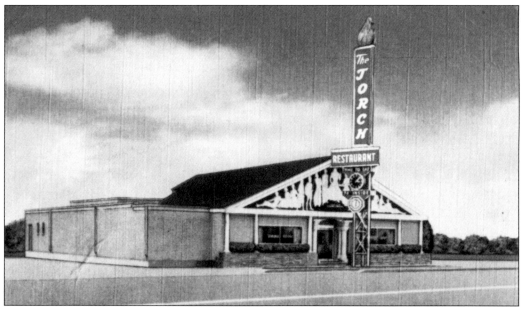

THE TORCH RESTAURANT. Operated by the Semos family from 1948 to 1986, the Torch Restaurant was an Oak Cliff landmark. Victor Semos of Naspactos, Greece, created the first Greek restaurant in Dallas, offering authentic Greek cuisine. The Torch burned in 1970, destroying the restaurant and Semos's collection of Greek paintings and sculptures. Undaunted, Semos operated at an Oak Lawn location while rebuilding the original location at 3620 West Davis Street.

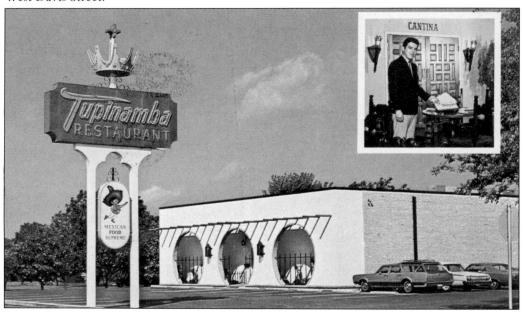

TUPINAMBA RESTAURANT. Sonny Dominguez began the Tupinamba dynasty in 1947 at 2131 Fort Worth Avenue in Oak Cliff. He left Mexico at the age of nine during the revolution. Dominguez, who learned the restaurant business at El Fenix, developed the much-loved Tex-Mex treat, the Tupy Taco—a deep-fried crescent stuffed with beef. The Dominguez family closed this location in 1973 and sold the equipment to another restaurant called Benavides.

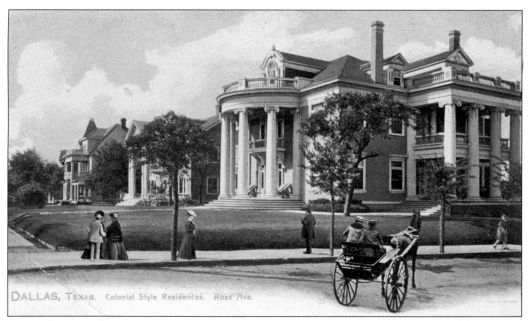

ROSS AVENUE RESIDENCES. From 1885 to 1920, Ross Avenue was Dallas's Fifth Avenue. The silk-stocking district, lined with mansions, was occupied by the city's civic and business leaders. But encroaching commercial uses gradually drove the wealthy farther north and east to carefully designed residential developments such as Highland Park and Munger Place. Today only the Belo Mansion survives as a reminder of the street's former nature.

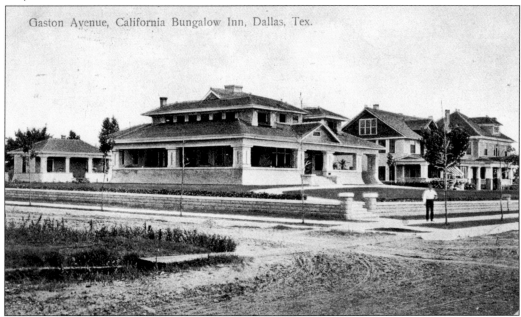

GASTON AVENUE RESIDENCES. Originally part of the early-20th-century Munger Place development, Gaston Avenue rivaled Swiss Avenue as the location for many of the city's finest mansions, designed by noted architects for business and civic leaders. Most of the grand homes lining Gaston were razed following World War II for the construction of apartments. Swiss Avenue nearly suffered the same fate but was saved by the diligent work of homeowners.

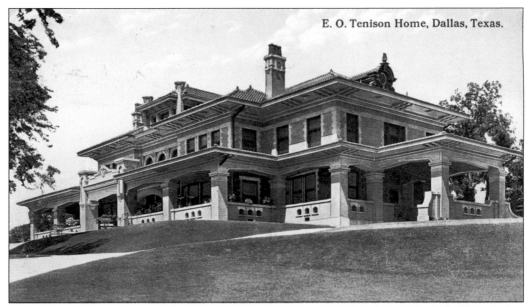

E. O. Tenison Home, Dallas, Texas.

E. O. Tenison Home. Banker E. O. Tenison commissioned architect C. D. Hill to design his family's residence in 1908. Situated on an elevated slope of land overlooking Turtle Creek, Hill's creation merged elements of Prairie and Spanish Colonial styles. In 1927, after Tenison and his wife died, the American Life Insurance Company had offices here. The Tenison home was razed in 1947 and replaced by the Gulf Insurance Company Building.

Potts House, 5311 Nakoma Drive. Dallas boomed after World War II, and residential construction mushroomed to keep up with the demand. This enterprising couple printed their own photographic postcard announcing the purchase of their new home in Greenway Parks. Sadly this charming Mid-Century Modern home has recently been replaced by a much larger contemporary house, which is part of the trend of "tear downs" in desirable residential neighborhoods.

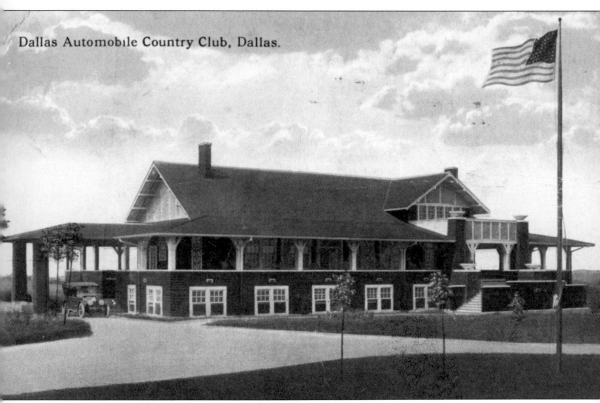

Dallas Automobile Country Club, Dallas.

DALLAS AUTOMOBILE COUNTRY CLUB. As automobiles became the rage, clubs devoted to riding quickly formed, prompting a need for clubhouses where members could relax, socialize, consult maps, and gather information for their excursions. After years of debate regarding a suitable site, construction of the Dallas Automobile Country Club commenced and was completed in 1914. The clubhouse was erected near today's intersection of Central Expressway and Walnut Hill Lane, which was a remote area at the time. Built for approximately $22,000, the clubhouse had a wraparound balcony and a basement with lockers, bowling alleys, indoor golf facilities, smoking rooms, grill room, and a separate room for dinner parties. In 1922, Dallas Automobile Country Club was rechristened Glen Haven Country Club. Its name changed again in 1933 when a new club, Glen Lakes, acquired Glen Haven. As Dallas expanded northward, the club's future was at stake. By 1978, the Glen Lakes Country Club had given way to commercial and residential development, and the clubhouse was demolished.

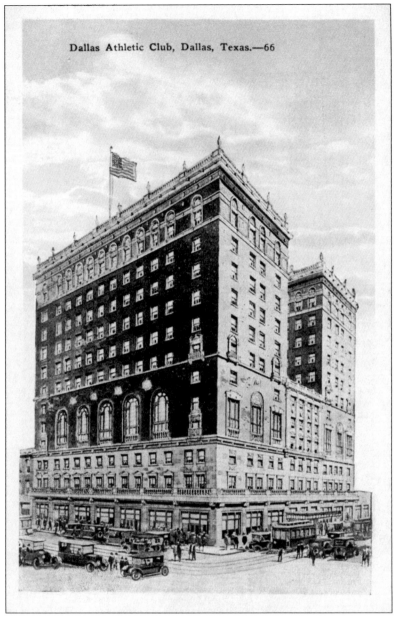

Dallas Athletic Club, Dallas, Texas.—66

DALLAS ATHLETIC CLUB. For more than 50 years, the Dallas Athletic Club (DAC) at 207 North St. Paul Street provided members a place for swimming, bowling, dining, boxing, dancing, and a host of other activities. Soon after the club was chartered in 1920, the board of directors launched a membership campaign to help raise funds for a building. A special committee, composed of five club members, embarked on a tour that same year to meet with officials of other athletic clubs. Prominent Dallas architects Lang and Witchell were chosen to complete the lavish Sullivanesque-style building in 1925. The club included space for stores, offices, and apartments. With the growing popularity of country clubs in the post–World War II era, the attractions of a downtown athletic club dwindled. In 1953, the DAC opened a 350-acre country club on Barnes Bridge Road, leaving the beautiful downtown building in 1978 to be demolished.

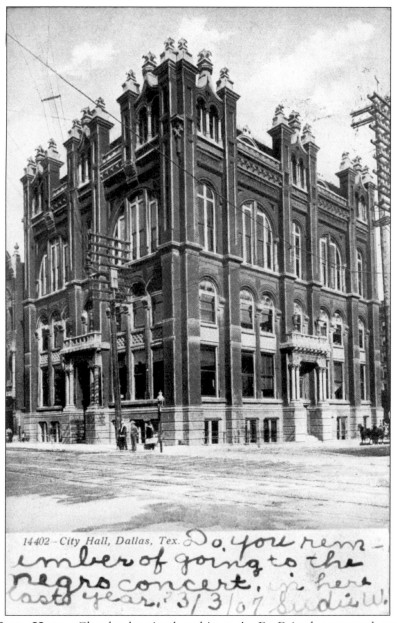

14402 – City Hall, Dallas, Tex. Do you rem- ember of going to the negro concert, in here last year. 3/3/07 Sudie W.

DALLAS CITY HALL. Cleveland-trained architect A. B. Bristol competed against three other architectural firms to win the commission for the third city hall, a three-story brick and sandstone building that was constructed at a cost of $80,000 on the northwest corner of Commerce and Akard Streets. Completed in 1888, the building's architecture was an innovative combination of Romanesque Revival with Gothic Revival influences, featuring brick pilasters that terminated in potted-plant roof finials. The interior was richly appointed with cherry, oak, and black walnut wood and Brussels carpets. The two-story council chamber held stained-glass windows with an elaborate wood-paneled ceiling from where an enormous chandelier hung. The third floor held an auditorium with a seating capacity of 1,000. Sudie Williams, director of music for the Dallas school system, wrote the note about the concert at Dallas City Hall. It was demolished in 1910 to make way for the Adolphus Hotel.

WEICHSEL Co. URSULINE CONVENT, DALLAS, TEXAS.

HAND-COLORED

URSULINE CONVENT. This High Victorian Gothic building with its commanding bell tower served Dallas Catholics as a girls' preparatory school for more than 50 years. The school was established in 1874 by Ursuline nuns from Galveston who followed in the tradition of St. Angela Merici. The building, which cost $250,000, filled a 9-acre site bordered by Live Oak Street, Haskell Avenue, Bryan Parkway, and St. Joseph Street. Architect Nicholas J. Clayton, who designed the Bishop's Palace as well as other Galveston structures, is credited with the design for the main tower building, which was started in 1882 and completed in 1884. W. H. Harrell, a Dallas architect, utilized Clayton's plans and oversaw the construction of the two wings built in 1889 and 1902. Beard and Stone Electric acquired the property and demolished the building in 1950. Ursuline relocated to Walnut Hill Lane, where it incorporated the original cornerstone and bell from the bell tower in the new complex.

THE MARSALIS SANITARIUM DALLAS TEXAS

MARSALIS SANITARIUM. Thomas L. Marsalis, founder of Oak Cliff, intended this three-and-a-half-story Queen Anne mansion at 825 Marsalis Avenue, replete with turret and spindle-work ornamentation, as his residence but was unable to complete it due to financial reverses. Dr. J. H. Reuss purchased the building at auction to use as a sanitarium in 1904. It later served as a girls' school. The mansion was destroyed by fire in 1914.

St. Paul Sanitarium, Dallas, Texas.

ST. PAUL SANITARIUM. When the Sisters of St. Vincent de Paul opened St. Paul Sanitarium in 1898, it was the first hospital in Dallas with hot and cold running water and electricity. Constructed at the height of the Victorian period, the Romanesque Revival three-story building designed by H. A. Overbeck boasted a mantel in every room. The hospital, at 3121 Bryan Street in East Dallas, was demolished in 1968.

124

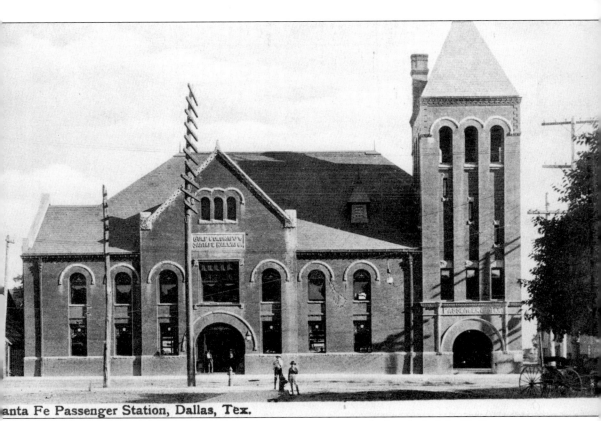

SANTA FE PASSENGER STATION. Part of the railway crossroads that fueled the Dallas economy a century ago, the Santa Fe built this station in 1897 on Commerce Street at Murphy Street. Although it had luxurious features such as marble flooring and a Fred Harvey restaurant, the station suffered logistical problems: trains had to cross three downtown streets (Young, Wood, and Jackson) to go back into the station from the south. As more automobiles clogged downtown streets, it became clear that cars and trains did not mix well, and a movement started to move all railroad tracks to the periphery of the central business district and establish a central or union station. Barely 20 years after it opened, this station was abandoned for the new Union Station on Houston Street. The Santa Fe demolished this building but maintained control of the swath of land previously occupied by the terminal and tracks, erecting a series of four office and warehouse buildings and moving the tracks underground. Three of those four buildings still stand and are in use today. (Courtesy DPL.)

BIBLIOGRAPHY

Dallas Morning News online archive.

Fuller, Larry Paul, ed. *The American Institute of Architects Guide to Dallas Architecture with Regional Highlights.* Dallas: Dallas Chapter of the American Institute of Architects, 1999.

Galloway, Diane, and Kathy Matthews. *The Park Cities: A Walker's Guide and Brief History.* Dallas: Southern Methodist University Press, 1988.

Greene, A. C. *Dallas: The Deciding Years—A Historical Portrait.* Austin, TX: The Encino Press, 1973.

Hazel, Michael V. *Dallas: A History of "Big D."* Austin, TX: Texas State Historical Association, 1997.

———, ed. *Historic Photos of Dallas.* Nashville: Turner Publishing, 2007.

Holmes, Maxine, and Gerald D. Saxon, eds. *The WPA Dallas Guide and History.* Denton, TX: Dallas Public Library, Texas Center for the Book, University of North Texas Press, 1992.

McDonald, William L. *Dallas Rediscovered: A Photographic Chronicle of Urban Expansion, 1870–1925.* Dallas: The Dallas Historical Society, 1978.

Minutaglio, Bill, and Holly Williams. *The Hidden City: Oak Cliff, Texas.* Dallas: Elmwood Press and the Old Oak Cliff Conservation League, 1990.

Payne, Darwin. *Big D: Triumphs and Troubles of an American Supercity in the 20th Century.* Dallas: Three Forks Press, 2000.

———.*Dallas: An Illustrated History.* Woodland Hills, CA: Windsor Publications Inc., 1982.

———.*Dynamic Dallas: An Illustrated History.* Carlsbad, CA: Heritage Media Corporation, 2002.

Ragsdale, Kenneth B. *The Year America Discovered Texas: Centennial '36.* College Station, TX: Texas A&M University Press, 1987.

Saxon, Gerald D., ed. *Reminiscences: A Glimpse of Old East Dallas.* Dallas: Dallas Public Library, 1983.

Wiley, Nancy. *The Great State Fair of Texas: An Illustrated History.* Dallas: Taylor Publishing Company, 1985.

SPONSORS

Dallas Heritage Village at Old City Park is an award-winning history museum established by the Dallas County Heritage Society in 1966. The village specializes in Dallas-area history and heritage from 1840 to 1910 and is located on 20 acres in the Cedars neighborhood in downtown Dallas. Pioneer and Victorian Dallas are seen through 38 restored-and-decorated historic buildings in a village setting. In the fall and spring "Living History Seasons," the village highlights and brings important historical topics to life through first-person characters dressed in period clothing, special events, and exhibits. Dallas Heritage Village programs include self- and docent-guided tours, special events, adult lectures, classes and camps for children, and a heritage livestock program.

Preservation Dallas is a private, nonprofit organization dedicated to the preservation and revitalization of Dallas's buildings, neighborhoods, and other historical, architectural, and cultural resources. Founded in 1972, Preservation Dallas has a successful history of saving some of our community's finest landmarks. We work to rescue and protect our city's heritage through public awareness and education, downtown revitalization, neighborhood support, and through the Discover Dallas! architectural survey, which identifies historic neighborhoods and significant architecture from the 19th century through the mid-1960s. Preservation Dallas is supported by generous contributions from the Meadows Foundation, which owns and maintains the Wilson Block Historic District on historic Swiss Avenue and the Wilson House, home of Preservation Dallas. The Wilson House is open for tours and research Tuesday through Friday.

ACROSS AMERICA, PEOPLE ARE DISCOVERING
SOMETHING WONDERFUL. *THEIR HERITAGE.*

Arcadia Publishing is the leading local history publisher in the United States. With more than 4,000 titles in print and hundreds of new titles released every year, Arcadia has extensive specialized experience chronicling the history of communities and celebrating America's hidden stories, bringing to life the people, places, and events from the past. To discover the history of other communities across the nation, please visit:

www.arcadiapublishing.com

Customized search tools allow you to find regional history books about the town where you grew up, the cities where your friends and family live, the town where your parents met, or even that retirement spot you've been dreaming about.